HEREFORD
THROUGH TIME

Derek Foxton

AMBERLEY PUBLISHING

First published 2009

Amberley Publishing Plc
Cirencester Road, Chalford,
Stroud, Gloucestershire, GL6 8PE

www.amberley-books.com

British Library Cataloguing in Publication Data.
A catalogue record for this book is available from the British Library.

ISBN 978 1 84868 479 9

Typesetting and Origination by Amberley Publishing.
Printed in Great Britain.

Introduction

Hereford is full of history and has a changing face that remains largely unrecorded. During the years 1950-1980 when planning laws were very flexible, the city lost many important buildings as developers disregarded much of our heritage and took advantage, demolishing anything they wished. The local authorities were often powerless to prevent such destruction and thus should not always be blamed. Today their powers and conservation area laws will hopefully preserve what is left of our heritage, as well as control future developments. We cannot live in the past and where there are no special reasons to conserve old buildings, we will get new replacements, hopefully with well thought out designs.

W. H. Smith's shop (page 13) contains a well-preserved timber framed building hidden behind a Victorian front. The original developer's proposal was to demolish the timber framed building but, as customers can now see, it is now an interior feature. In residential areas of the city we often see alterations to houses such as replacement doors and windows. Owners who use materials and designs similar to the original are to be congratulated.

Old picture postcards and photographs of Hereford are a valuable source of information and remind us of our heritage. Some of the original postcards and photographs reproduced are faded sepia prints and though not ideal for reproduction are included for their unique historic content.

During the early summer months of 2009 several civic events took place in the city and I have photographed these to add interest to otherwise rather plain views. In many of my photographs I have included motor cars, which tend to date pictures more accurately than buildings themselves; future generations will look at our present transport with interest in the same way as we look at the horse drawn carriages and carts in the old pictures throughout this book.

I hope that this book will be of interest to present day readers and provide some historical reference for future generations.

Acknowledgements

I wish to express my thanks to my wife Maria, for her patience, and help with the editing of this book. When I was in front of my computer I often missed calls for household chores.

I thank the following for help and permission to reproduce their photographs (not in order of merit), some of whom are no longer alive:

The Francis Frith Collection; The Dean, The Very Rev Michael Tavinor and Chapter of Hereford Cathedral; The Bishop of Hereford; Herefordshire Council; The Royal National College for the Blind; Roger Tingley; Bob Bowden; Keith James, Bustin Collection & Hereford Records Office; Marks & Spencer; Peggy Withington; Tim Ward; John Sweetman; Angus Jones; Peter Mountford; The Directors of W. H. Smith & Son Ltd; Richard Hammonds; Judith Salt; Jean O'Donnell; Donovan Wilson; Mr Bettington; Alan Simpson; Jean McAra and William Phillips of Cox's Cottage; *The Pubs of Hereford City*, Shoesmith & Eisel. Wherever possible, I have made every effort to obtain copyright permission.

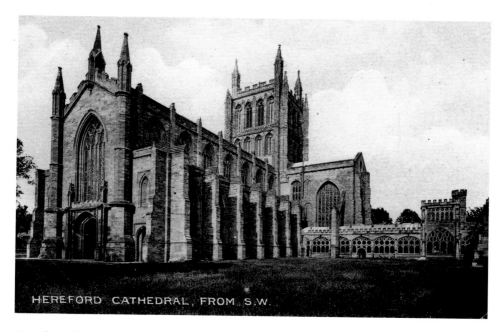

HEREFORD CATHEDRAL, FROM S.W.

Hereford Cathedral

Of Norman origin, the cathedral replaced an earlier church that was totally destroyed in 1055 by Welsh invaders. The west end of the Cathedral, insecure for many years, collapsed on Easter Monday 17 April 1786. The Dean at that time gave instructions to architect James Wyatt to remove the central tower spire and shorten the Cathedral by 15 ft. This shows the old west front by Wyatt. Alterations started about 1902 on the new west front, designed by Architect Oldrid Scott at a cost of £15,560.

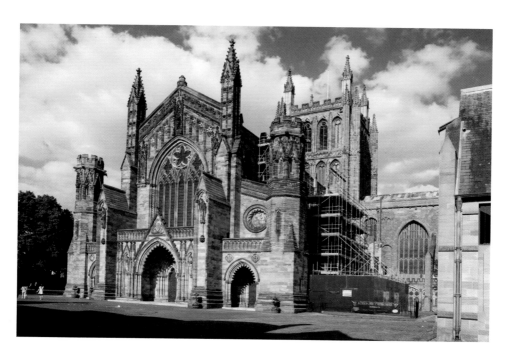

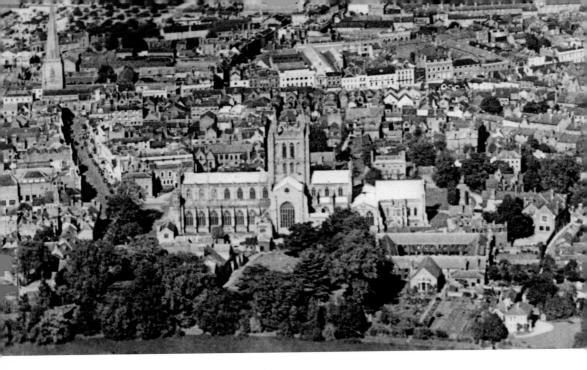

Aerial View of Hereford Cathedral

Hereford Cathedral has a prominent position on the north bank of the River Wye, with the Bishop's Palace in the foreground and trees along the riverbank in this 1932 photograph. The Lady Chapel seen to the right of the tower looks almost detached. To the left of the cathedral is a view along Broad Street to All Saints' church.

Today the Cathedral Close awaits a multi-million pound refurbishment.

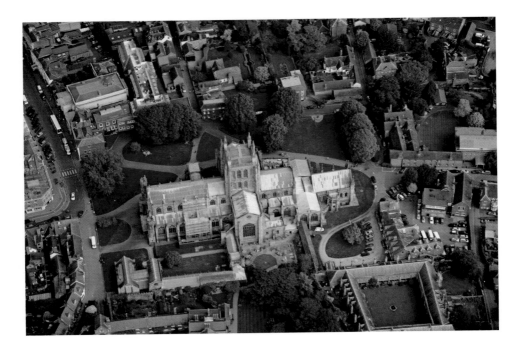

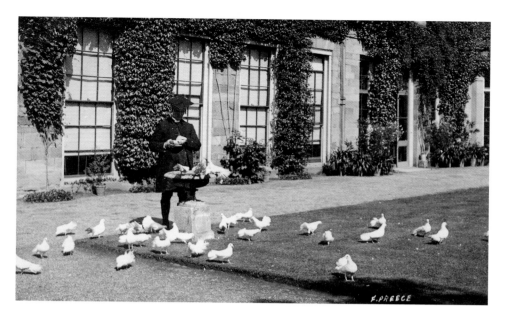

Bishop's Palace

This unidentified bishop – possibly Bishop Percival – is in the palace gardens with his doves. These gardens may have been the site of the Saxon Cathedral. The building behind the bishop is his palace, which contains some very early timbers and has long been recognised as being one of the most important Norman secular buildings in England dated *c.* 1185. Today, Bishop Anthony Priddis attends the 2009 May Fair opening ceremony (also see page 16).

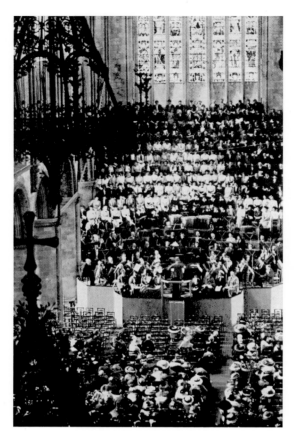

Hereford Cathedral Three Choirs Festival

A concert during the Hereford Three Choirs Festival in 1912, photographed from a gallery in the cathedral tower showing conductor G. S. Sinclair, aged forty-eight. This was the year that Elgar composed the suite from the Crown of India, which had its first performance here. Many of Elgar's compositions were first performed at the Three Choirs Festival during his lifetime. Geraint Bowen, Hereford cathedral organist and music director, conducts the opening service for the 2006 Hereford Three Choirs Festival.

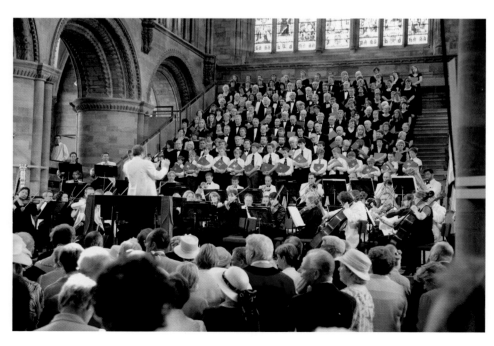

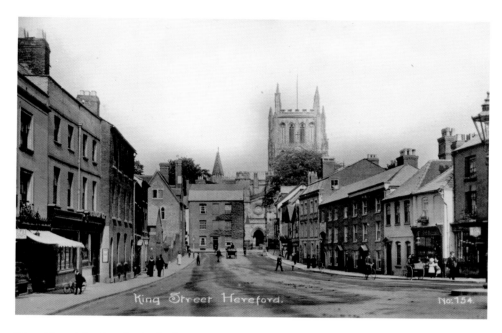

King Street to the Cathedral

Nearly the whole length of King Street is visible on this early 1900s picture. Note the buildings on the Cathedral Close in front of the cathedral. In April 1937 this house and its attached neighbours caught fire while awaiting demolition. The buildings were demolished using funds donated by Col. Haywood of Caradoc Court, thus making the west front of the cathedral visible from Broad Street and King Street.

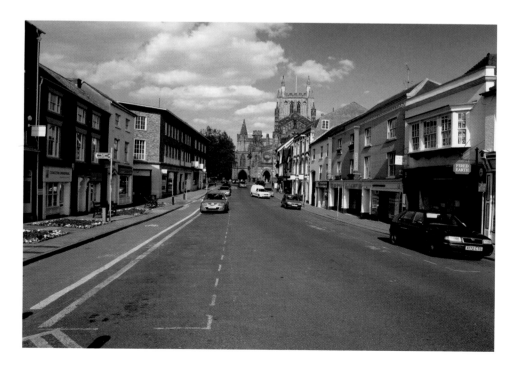

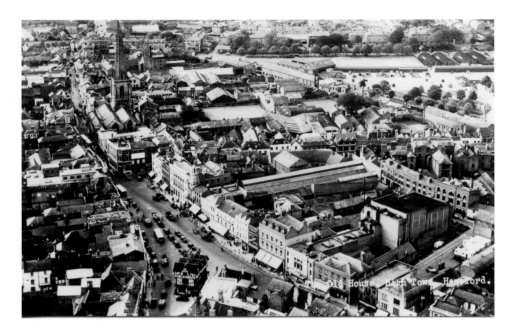

Aerial View of High Town

High Town and part of Commercial Street (to the lower right corner) are on this 1940s aerial view. The Old House is clearly visible near the centre lower edge with All Saints' church and spire to the top. Also seen is the long roof of the Butter Market with Maylord Street to the centre right. Today in the foreground of this near vertical view is Marks and Spencer, while at the top is Maylord's Orchards.

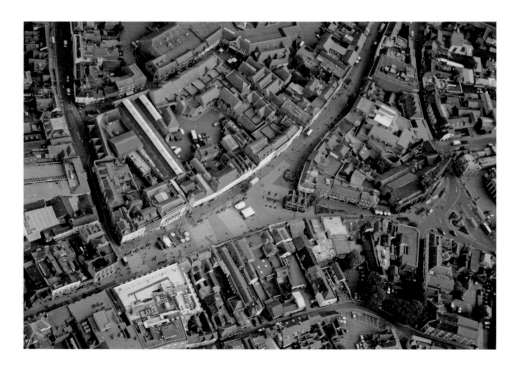

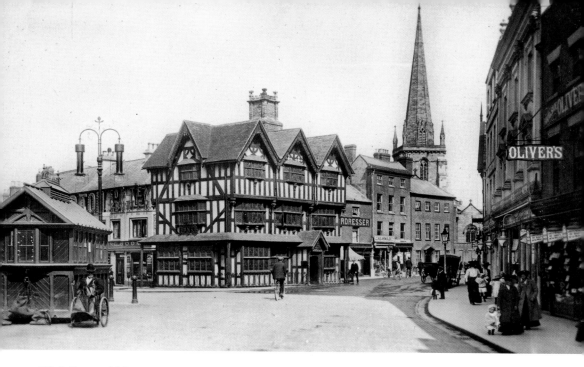

High Town Old House

This must be the second most common picture of Hereford. It is of the Old House, built in 1621. The hut is one of two that were used by the city's cabbies. Judging by the long costumes, the postcard would date from the early years of the twentieth century. The Old House has been restored several times since it was donated to the city by Lloyds bank in 1929. Today it is a museum, open to visitors free of charge.

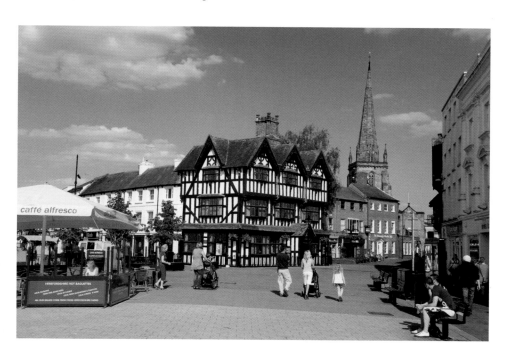

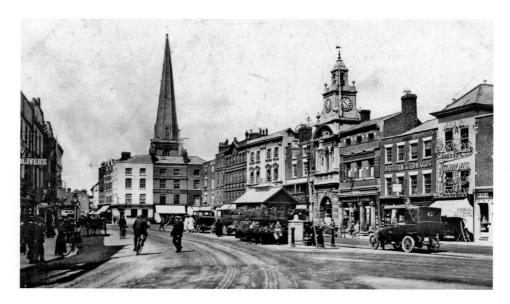

High Town to High Street

High Town about 1920 with the motor taxis awaiting their fares. All Saints' church tower and steeple base are undergoing restoration. The buildings to the left of the Butter Market Hall were demolished in 1928 by Lloyds Bank. The Butter Market entrance and clock tower was opened 10 October 1860. A superb black and white half-timbered town hall on wooden pillars stood in the middle of High Town, but it was sadly demolished in 1862. High Town is now a paved pedestrian precinct.

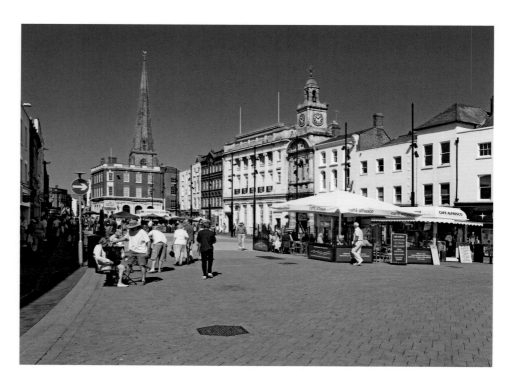

High Town Shops

In 1895 the occupants of 24 and 25 High Town were Albert Townsend, cutler and optician, and William Pearce, grocer. 25 High Town, which had a Bath stone front 27ft wide and extended through to East Street 169ft in depth, was let to Mr Pearce at £15 per annum. By 1922 no. 24 was occupied by Frank Stewart, watchmaker and no. 25, by George Mason, grocers. Today's W. H. Smith's store opened in March 1991.

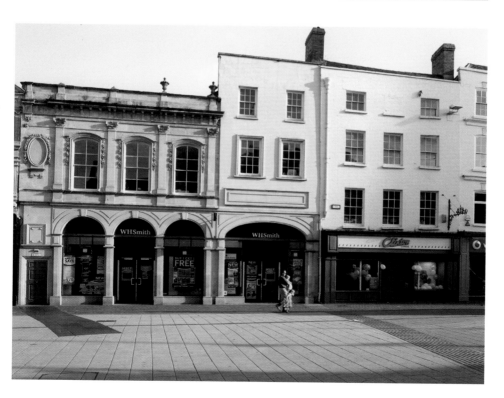

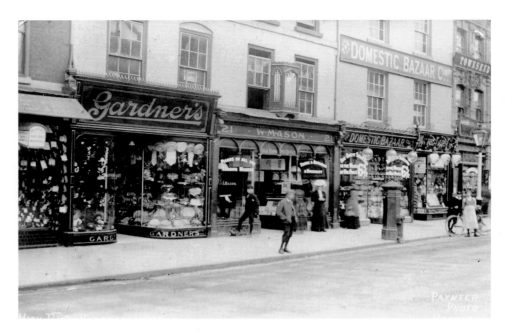

High Town Shops, South Side

The south side shops of High Town before the First World War. Gardner's at no. 20 were milliners, Mason, a music warehouse and sub-post office. Note the old pipe organ on the first floor level between the windows where there was a music shop. The Domestic Bazaar sold glass and china. Next door was the Maypole Dairy Co. and, finally, on the far right was Townsend's, an optician and bicycle agent.

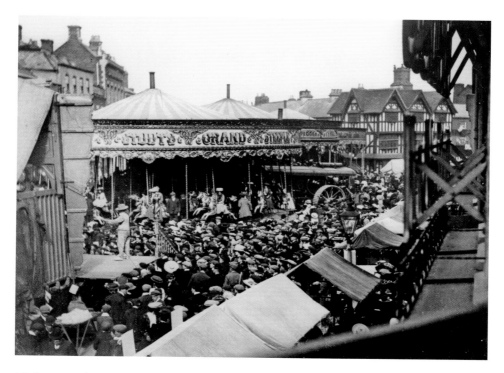

High Town during the May Fair

The May fair is traditionally held on the streets of the city centre during the first week of May. This photograph, taken by Mr E. J. Paynter, was published in the *Hereford Times* on 25 May 1907. The roundabout in the centre is the Grand Steeplechase Gallopers. The traction engine, though not of the usual showman's type, was used to pull the wagons from town to town and generated power. This photograph was taken from Marks & Spencer.

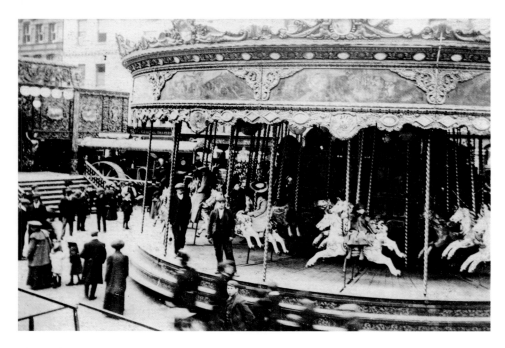

May Fair

The City of Hereford has to allow an annual street fair every May, according to a charter by Henry I to Richard de Capella, Bishop of Hereford, granting him the right to hold a three day May Fair every May. In 1838 an Act of Parliament gave control of the fair to the citizens, and the bishop was compensated by an annual payment of 12½ bushels of best wheat. Today the fair still incorporates many of the old roundabouts (see also page 7).

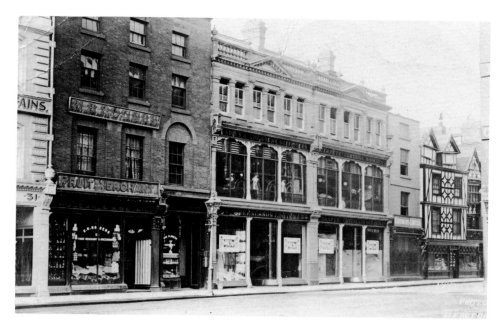

High Town in 1907

On the left of the picture is Greenlands (soft furnishers) with Rodgers next door, a fruiterer. Behind the lamppost is the entrance to Rudolph Siever, a surgeon dentist. Greenlands owned the next two shops in the light coloured building with Marchant's on the right. The scene has changed dramatically. Even the oldest part of the front of Marchant & Matthews old shop, now integrated into the New Look premises, has been moved a gables width to the left.

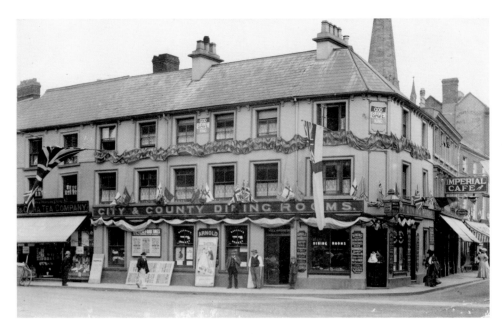

The City and County Dining Rooms, High Town

Mr Henry Jones was manager here in about 1910. He had a prime site in the city centre, facing High Town and the Old House. The banners proclaim 'God Save the King'. The occasion is unknown, but it could be the coronation of King George V. The ladies are wearing full-length costumes. The building was restored by the Cheltenham and Gloucester Building Society and is now a coffee shop.

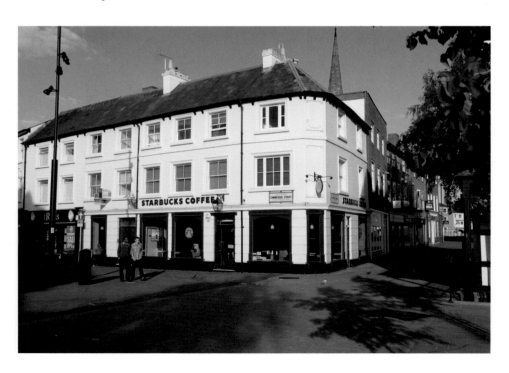

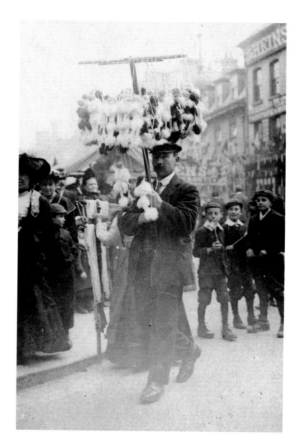

Broad Street Souvenir Seller
The fairground souvenir seller has an admiring audience of children, who have possibly spent all their pocket money. In the background can be seen the sign of Heins music shop in Broad Street. The balloon seller – a regular visitor for over twenty-five years – provides a colourful picture. Like her predecessor, she stands in the middle of the May Fair but this time in High Town.

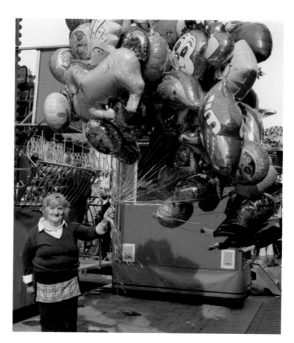

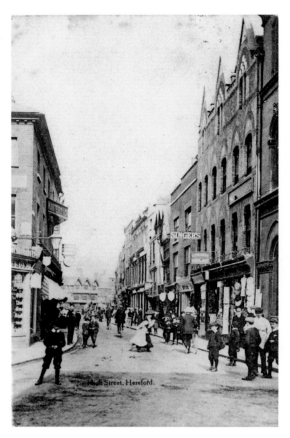

High Street

A small boy watches the photographer in this High Street picture with the Old House in the distance. All traffic through the city used this narrow road until the opening of the inner relief road, 11 December 1968. The shops are closed so it is probably a Sunday. The trading sign 'Singers' refers to the popular sewing machine still in use today. Today, High Street is pedestrianised between 10.30 a.m. and 4.30 p.m.

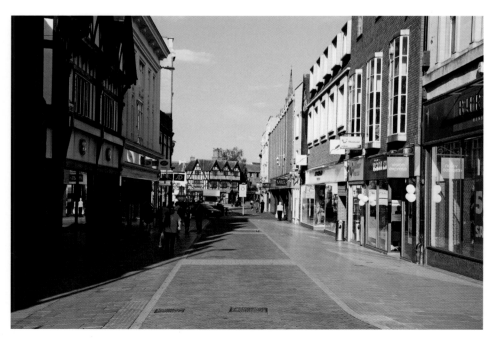

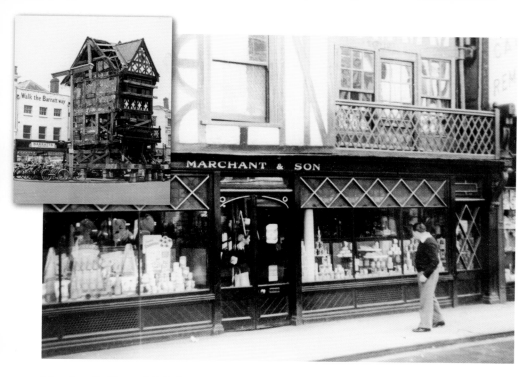

Marchant's Shop, High Street

In High Street, Marchant's old shop front was partly original seventeenth-century and late nineteenth-century replica timber. Many Herefordians will remember the smell of freshly ground coffee outside near the extraction fan. In 1967 Littlewoods purchased Marchant's shop, next to their premises, with a view to demolishing both and building a new store on the site. The oldest part was put on wheels and moved into High Town for some months while the new store was built.

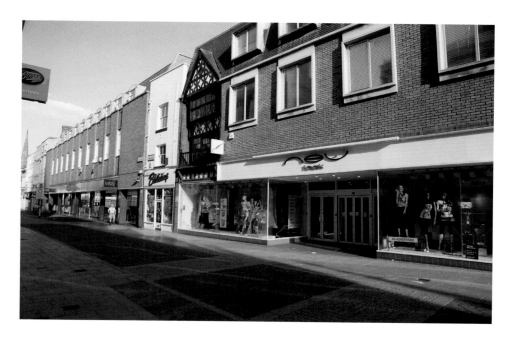

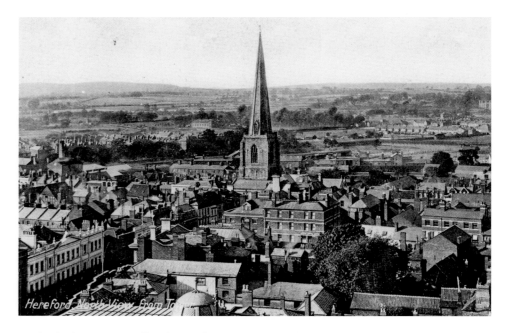

Cathedral Tower to All Saints' Church

An unusual view from the top of the cathedral tower, along Broad Street (on the left) and with All Saints' church in the centre. The dome is on St Francis Xavier's church roof. The gasworks at Mortimer Road, which opened in 1873, are visible to the right of centre. On close inspection many changes are now seen, especially the old British Telecom building in Church Street (now part of the Hereford Cathedral School) near the lower border and Bulmer's Cider storage tanks in the distance.

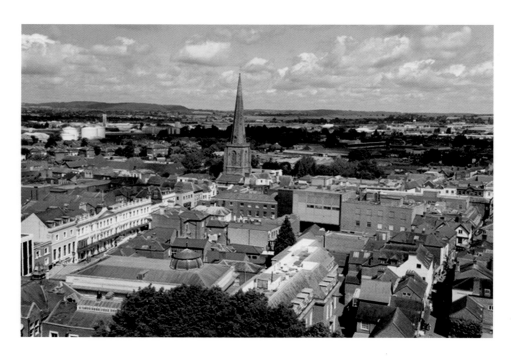

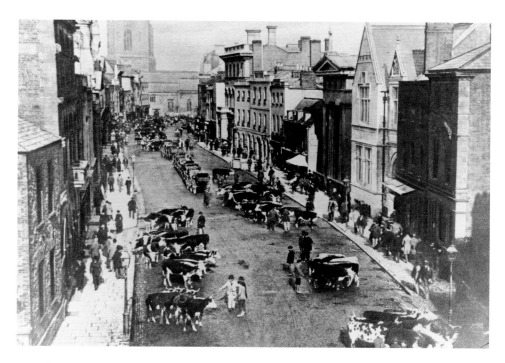

Broad Street Cattle Market

A cattle fair was held periodically in Broad Street. This photograph dates from the 1880s and about thirty heads of cattle are seen in the foreground, with many more in the distance. In between is a line of some ten horse-drawn 'taxi' cabs. The road surface looks well manured and there are pedestrians on the pavement. Note the newly built post office on the right.

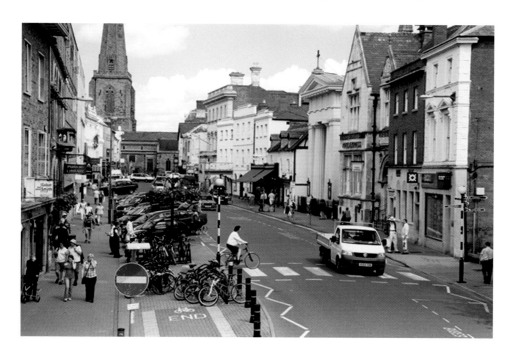

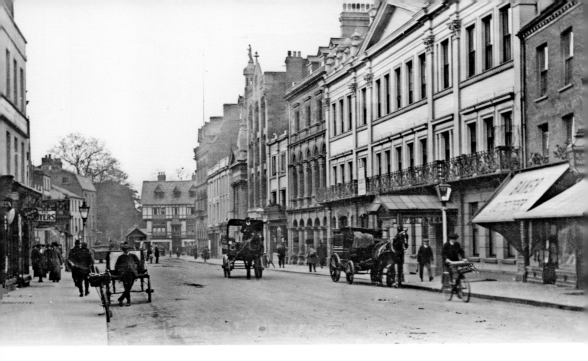

Broad Street, View to the South

Note the motive power for the vehicles in Broad Street. The two horse-drawn vehicles and one hand cart indicate a quiet day in the street. The gas lamps look as if they are alight so it could be late afternoon. The majestic front of the Green Dragon Hotel dominates the view. Just visible past the Green Dragon Hotel are several replacement buildings of questionable design. One was built for the Inland Revenue.

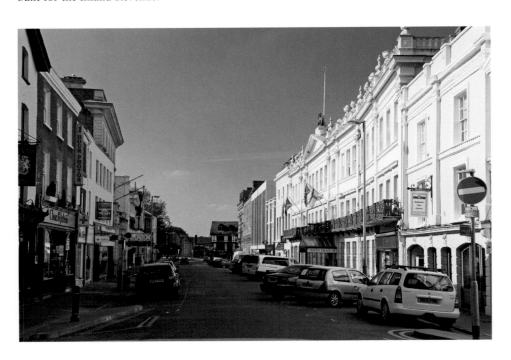

Broad Street,
View to All Saints' Church

Broad Street before the turn of the century, with a horse drawn two-wheeled cart. The hut the middle of the street was a shelter used by the cabbies for rest and dry storage of hay. The old hut was moved to Bishops Meadows tennis courts, where it was used by council attendants. Early in April 2001 it was, sadly, demolished by Herefordshire Council.

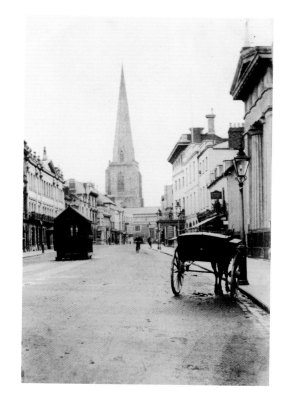

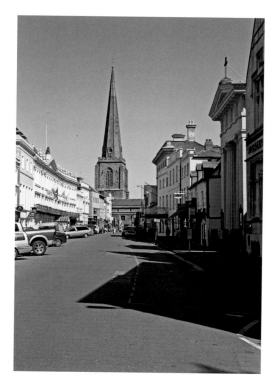

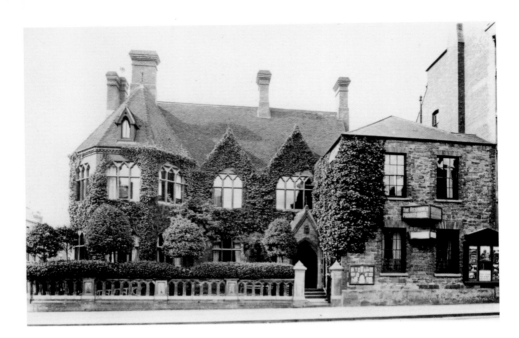

Residence Hotel, Broad Street

The 1914 local trade directory described this building at the corner of King Street and Broad Street as Residence House, home to the 'canon residentiary and prebendary, the Rev. Rashdall'. Later it became the Residence Private Hotel. It is a fine looking Victorian building with some gothic influence. Today we see two estate agents under the same roof. This architecture is perhaps far from what this site deserves, having the ancient cathedral opposite.

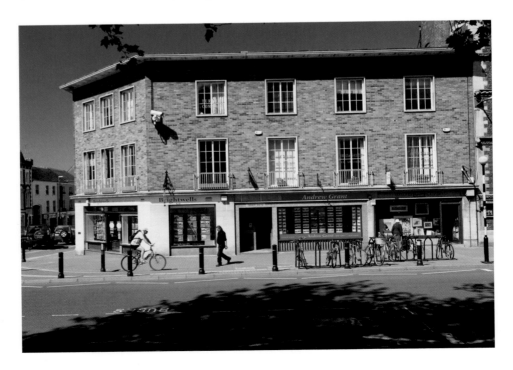

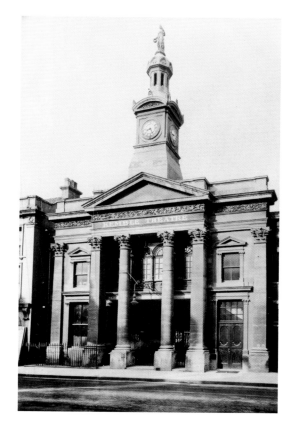

Kemble Theatre, Broad Street

This fine building, the Kemble Theatre, stood in Broad Street. Originally the Corn Exchange it had a Bath stone front and clock tower. It was enlarged in 1911 by adding a public hall and theatre at a cost of £5,000, and it seated 1,000. Today the name survives as Kemble House. A proposed heritage wall plaque will read 'Kemble Theatre. The Kemble family, including Sarah Siddons, performed in the first theatre (c. 1700). Replaced by Corn Exchange (1857) and Kemble Theatre (1911). Demolished in 1963'.

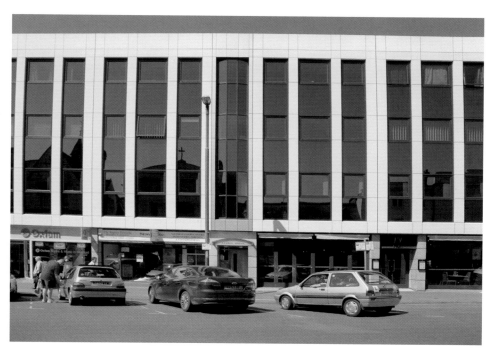

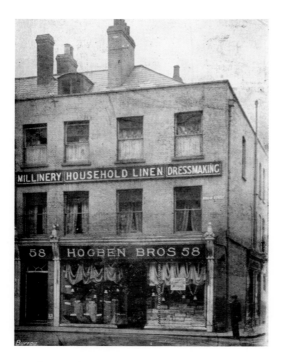

Hogben's Shop, Broad Street

'Hogben Bros' who sold hats, linen and fabrics were on the corner of Broad Street and Eign Street. This was a very good commercial position in the heart of the city centre. The London City and Midland Bank erected this building. For many years the firm Mac Fisheries (fishmonger and game dealer) occupied this site. The present occupant is F. Hinds, a jewellery shop.

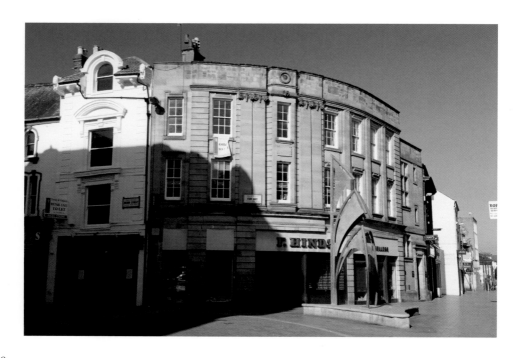

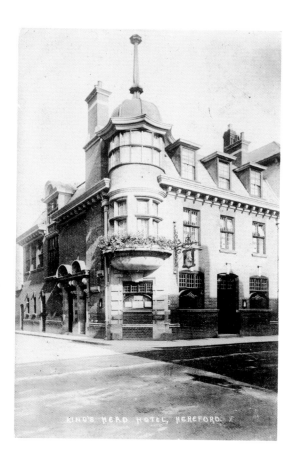

The King's Head Hotel, Broad Street

No doubt many Herefordians still remember this building, The King's Head Hotel, on the north-west corner of Broad Street and West Street. The landlord in 1907 was Alfred Willis. Hereford suffered a sad loss when it was demolished. The modern prefabricated facia does not do any justice to the city. Was this a modern act of architectural vandalism?

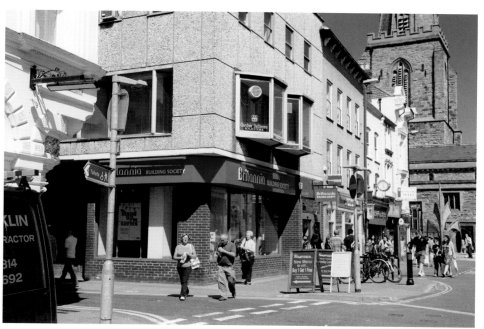

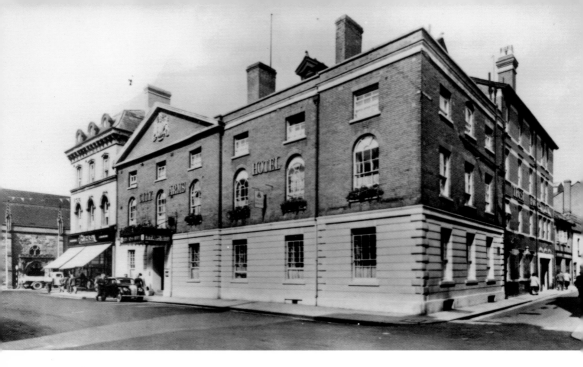

The City Arms Hotel, Broad Street

The City Arms Hotel was originally built (foundation stone laid in March 1791) by the Duke of Norfolk. In 1795 a new tenant, Mr Morgan, advertised that the name was now the 'City Arms Inn, Hotel and Tavern, late the Swan and Falcon'. It was purchased by Barclays Bank, who all but demolished the building. Only a small half-timbered rear room and the outer walls were retained. Note the extension in the same style along East Street.

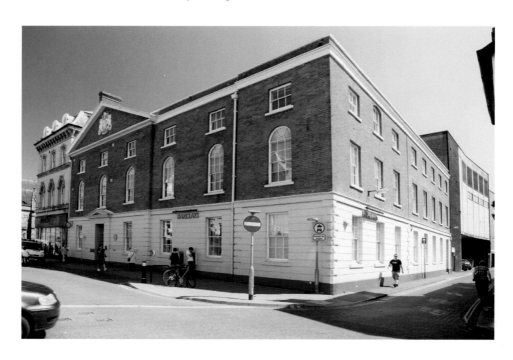

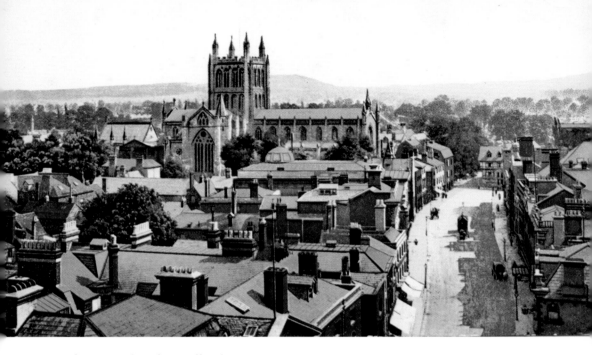

Broad Street, View from All Saints' Tower

A bird's eye view of Broad Street from the top of All Saints' church tower, taken in about 1930. The cathedral is dominant on the skyline. Note the profusion of chimneys. A cabbies' hut stands alone in the middle of the street. Today many of the chimneys have gone, removed before listed buildings and conservation area laws came into force.

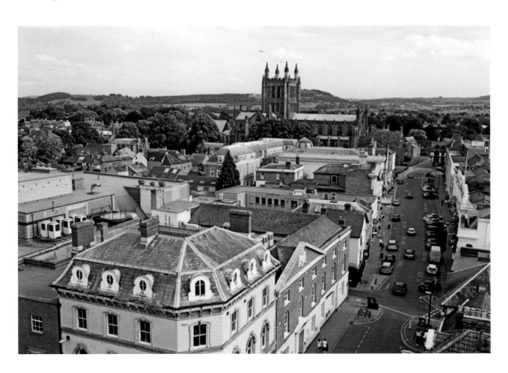

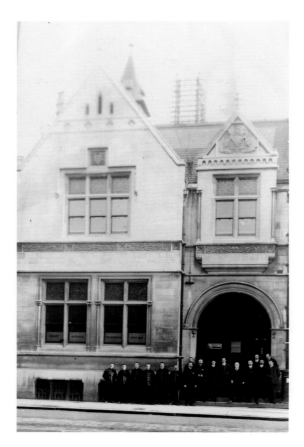

Broad Street Post Office
The main city post office in Broad Street was opened 20 December 1882 and cost £5,614. It has an interesting stone facia with some ornate features. Lined up in front are the post office staff with manager Samuel Ilsey. Nine workers are in tunics without a tie and eight with winged collars and ties. Today the building is used as a restaurant but the post box remains in use.

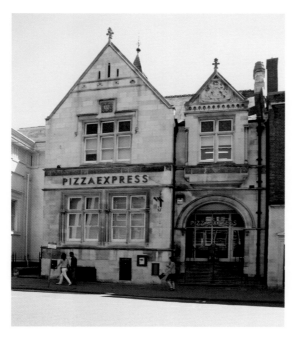

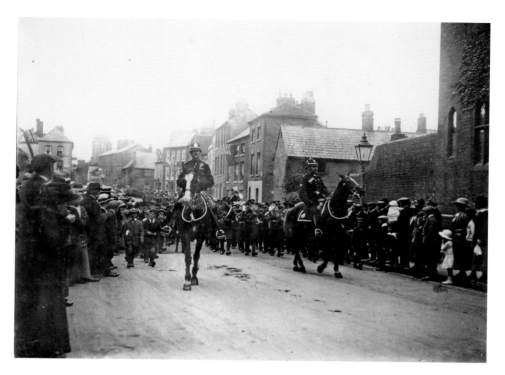

King Street Procession

A parade along King Street in October 1909, looking west. The two mounted policemen lead an army parade with a military band. Behind the horses, just visible in the background, is the St Nicholas' church tower that was re-erected in 1842. The church was originally on a site in King Street at the junction with Bridge Street. On the right is Thorpe House, built about 1965.

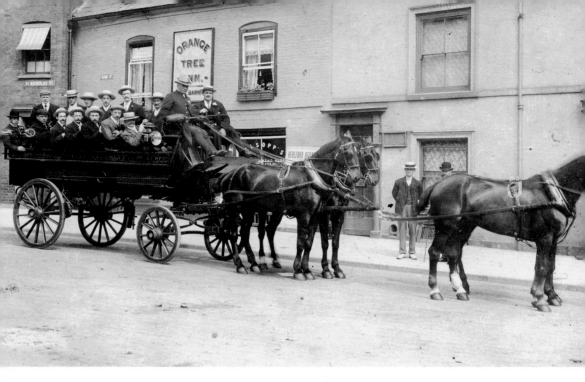

The Orange Tree, King Street

This superb picture from the turn of the century features four horses wearing their fine display of brass and the brake wagon with fifteen seated male passengers. The landlord at the time was George Barnham. The door on the right is the entrance into the photographer's studio Ladmore and Son. Note the twentieth-century alterations.

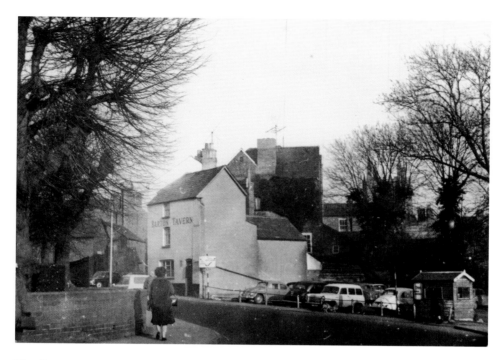

The Barton Tavern

The Barton Tavern in St Nicholas Street in 1960. In the distance once stood the old city gate, Friars Gate, and to the left is St Nicholas' church. Today, after forty years, the view is almost unrecognisable. In the foreground is the main A49 Greyfriars Bridge approach road, opened in 1968, and behind is a block of flats called 'Deans Court'. Note the old city walls.

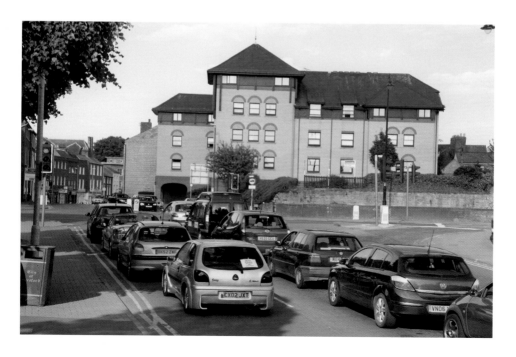

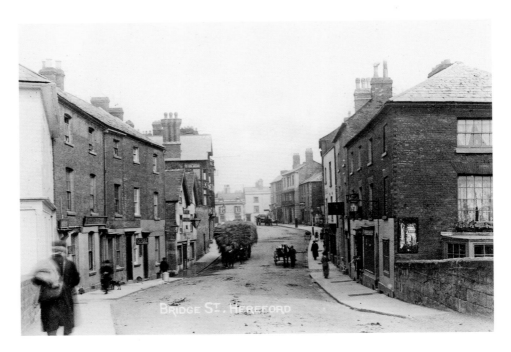

Bridge Street

Bridge Street with seven pedestrians, two dogs and three horse drawn wagons in August 1913. The Wye Bridge is in the foreground with Wye Bridge House on the left. Next door was Jordan the boat builder, next to which is the Black Lion. Further along this side of the street were six solicitors' offices. The shop on the right side next to the bridge was Henry Slann, a fruiterer. Today the Left Bank complex is on the right.

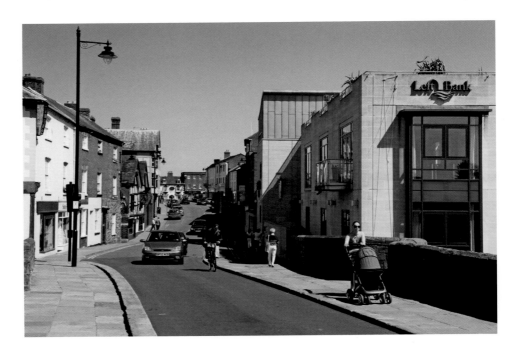

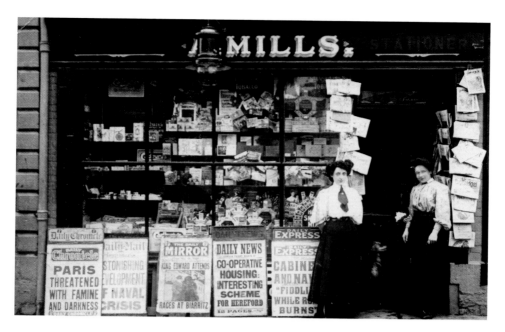

Mills' Shop, Bridge Street

Newspapers, cards, toys etc. are visible in this 1915 view of Mills' shop in Bridge Street. Mrs Mills stands on the right with her assistant. The newspaper headlines are as follows: 'Paris threatened with famine and darkness' from the *Daily Chronicle*; 'Astonishing development of naval crisis', the *Daily Mail*; and 'King Edward attends races at Biarritz', the *Daily Mirror*. Estate agents have now established themselves in this part of Hereford.

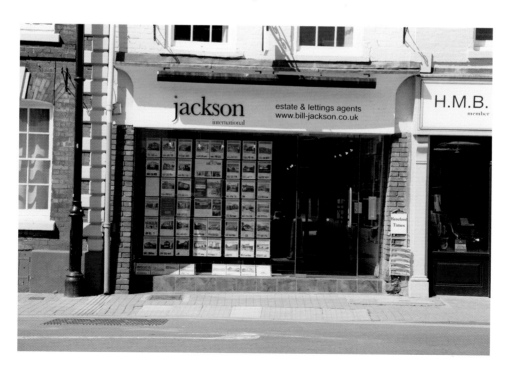

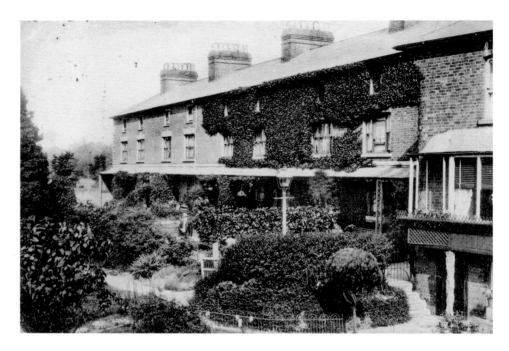

Wye Terrace, Bridge Street

Adjacent to the old bridge, Wye Terrace has one of the best views of the river in Hereford. Some of the houses have internal exposed timber framing. When the river is very high, the gardens and ground floors flood. Perhaps that is the reason for such healthy growth in the gardens! Today, during the summer months, the visitor has to stop and look between the trees to view Wye Terrace. The houses, however, still retain their river views.

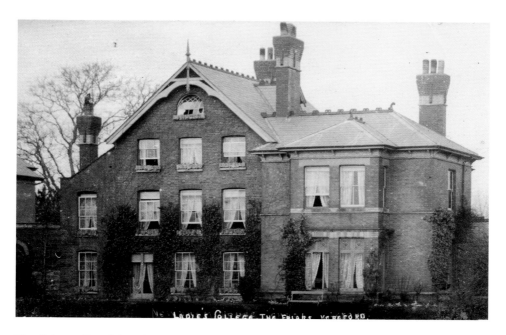

The Friars, Greyfriars Avenue

This large house, The Friars, dates from early Victorian times and stands on the riverbank, 200 yds upstream from the old Wye Bridge. Nearby is the lost site of the Grey Friars' monastery. About seventy years ago, during excavations for a new house in Greyfriars Avenue, some human remains were found. They are thought to be from the burial ground attached to the monastery.

This house was once the Greyfriars Restaurant, which closed down many years ago and has since become derelict.

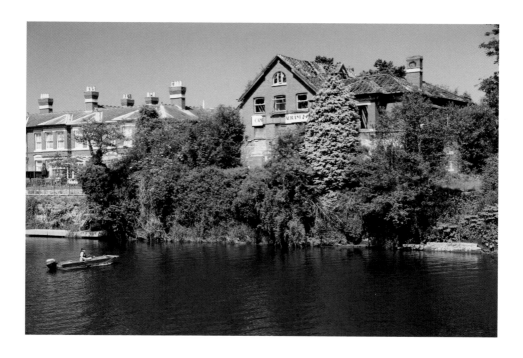

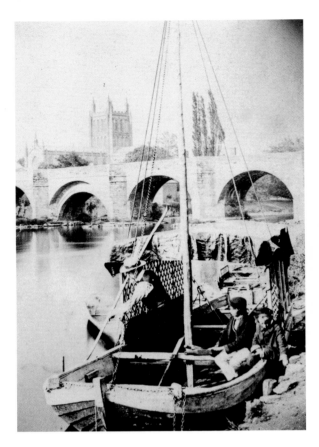

Wye Bridge

The River Wye has many rapids and shallow areas but was used for transport of goods only during high water. This is a rare glimpse of one of the last small river barges used to carry freight up and down stream from Hereford to Chepstow. In the 1880s a small, privately owned, steam-powered paddle pleasure boat was used here. Note the two small boys on board. Today river activities include rowing and canoeing.

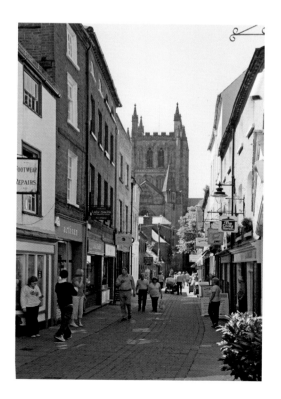

Church Street

Early morning in Church Street about 1935, with the cathedral as the focal point. In the far distance is a motor car, while in the foreground are a delivery bicycle and a handcart. The street between High Town and East Street has had many names: in 1220 it was known as Caboge Lane, in 1397 Cabache Lane and in 1757 Capuchin or Cabbage Lane. The street was one of the first city streets to be pedestrianised and paved from 'wall to wall'.

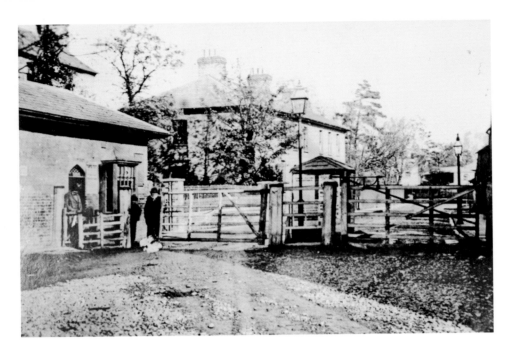

St Martin's Toll Gate

Hereford had several turnpikes, which were removed in 1870 when they were abolished. This picture of St Martin's would date before 1869. The turnpike keeper collected the tolls that went towards the upkeep of the highway. His chickens run on the road searching for food. Note how the gas lamp is positioned to illuminate the area and ensure that people cannot pass without payment. 2009 – what a transformation!

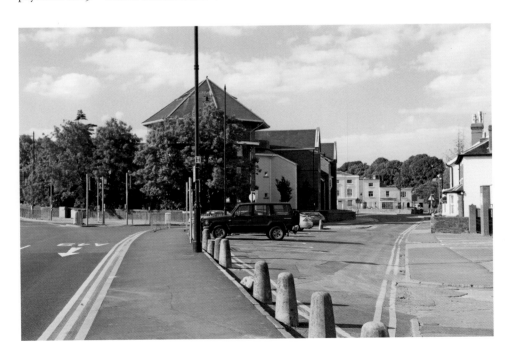

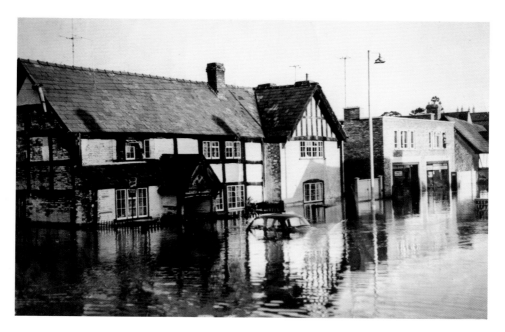

Pool Farm, Belmont Road

Following heavy rain or snow in the Welsh Mountains the River Wye will flood, as seen here on the Belmont Road outside Pool Farm. Note the cathedral pinnacles above the roof line. The car, possibly a Standard, must have had an expensive visit to the garage to return it to good working order. Hopefully the recently built flood barrier will eliminate the flood risk. Pool Farm dates from the early seventeenth century and is now a dental surgery.

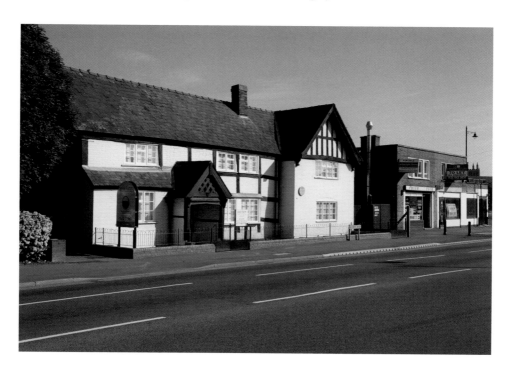

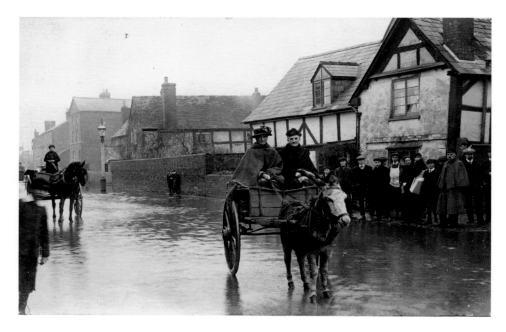

Causeway Farm, Belmont Road

The donkey pulling two elderly ladies in the cart seems undisturbed by the flood. This is Belmont Road and Causeway Farm during the 1912 floods. Some local residents watch the vehicles on their way into Hereford.

Causeway Farm has been demolished leaving Pool Farm in the distance. The new buildings incorporate shops with living accommodation over and are adjacent to the entrance to Asda.

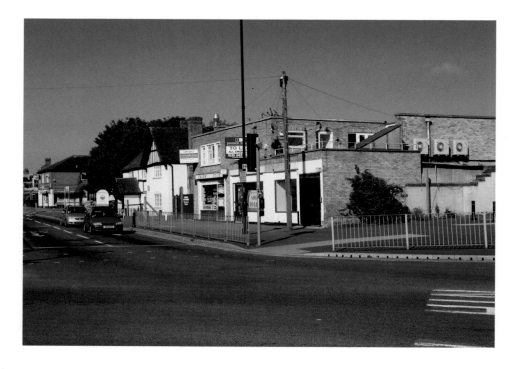

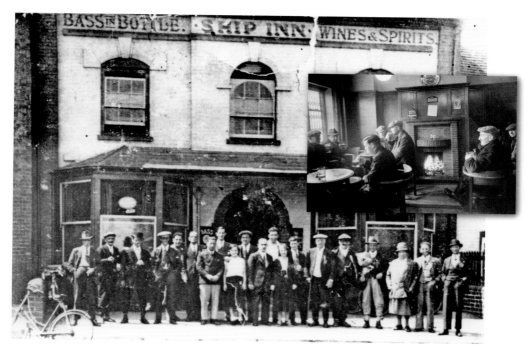

The Ship Inn, Ross Road

This old Ship Inn photograph was taken in the early 1930s showing its 'regulars', of whom none have been identified. Past landlord Jim Winters kindly loaned this photograph. Inset – several regulars enjoying a pint sometime in the 1950s. The Ship Inn was rebuilt in about 1938 to a classical public house design with mock half timbers and leaded glass windows. At present it awaits a new tenant and re-opening.

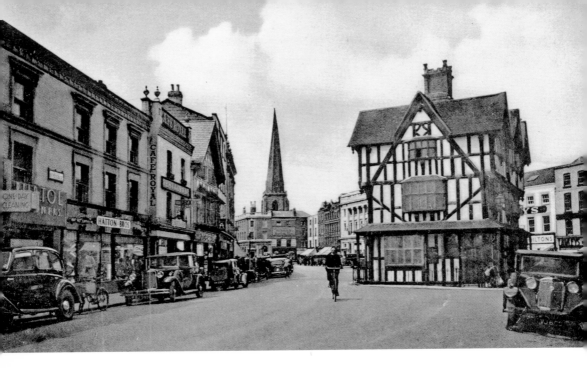

St Peter's Street to Old House

St Peter's Street about 1938, note the parked cars are pointing in both directions. This road went towards Ledbury and Fownhope. In 1928 the Old House was given to the city by Lloyds Bank, who had occupied it for many years. Today, Hereford's main post office is on the left with its cast iron post box visible adjacent to the raised flower bed. The mature trees now partly obscure the Old House.

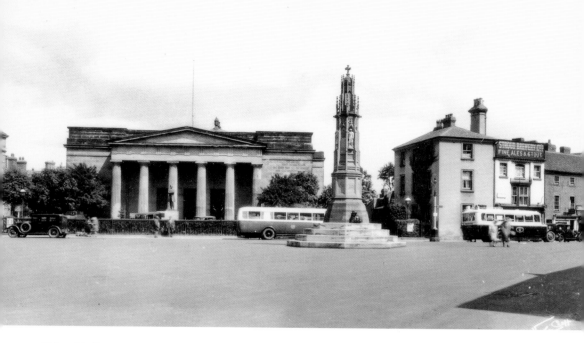

Shire Hall, St Peter's Square

St Peter's Square in about the 1930s – the heyday of the bus long before car ownership was widespread. The Shire Hall was erected in 1815 at a cost of £52,000 and opened in 1817. The Hereford War Memorial was unveiled 7 October 1922. The traffic now goes one way from Union Street into the square, but only buses are allowed to drive through to the left of the war memorial.

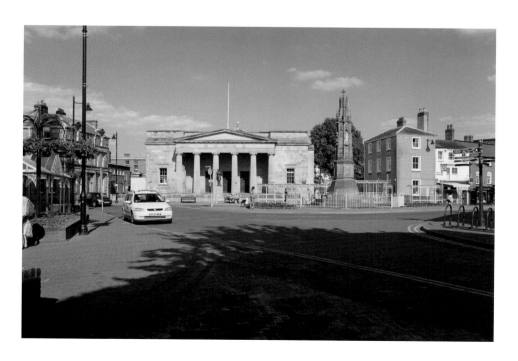

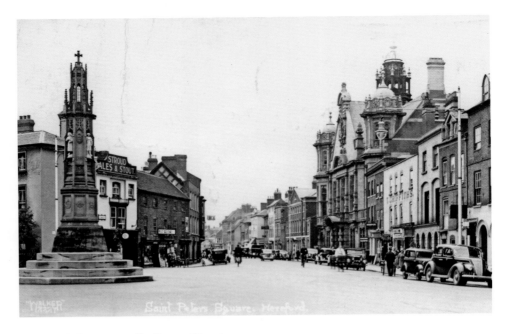

St Peter's Square to St Owen Street

The motor cars indicate that the date is about 1937. The town hall had its foundation stone laid by HRH Princess Henry of Battenburg on 13 May 1902, when Edward Bosley was the mayor. The flag pole turret stands stands high above the adjacent buildings

Today the view remains the same. Here the Mayor and Mayoress of Hereford, with Her Majesty's Lord-Lieutenant for Herefordshire, the Countess of Darnley, lead a civic procession.

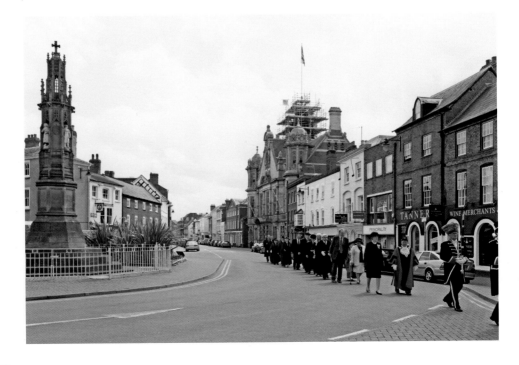

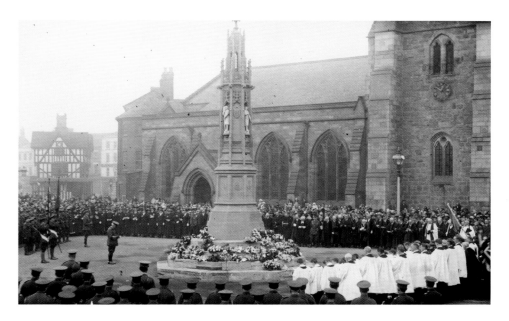

Remembrance Day, St Peter's Square

Following the end of the Great War, the city honoured its dead by erecting a temporary wooden cenotaph in High Town. This is the first service at the new stone memorial in St Peter's Square that was unveiled 7 October 1922 by Lieutenant Colonel Gilbert Drage, DSO, and Colonel M. J. Scobie, CB, of the Herefordshire Regiment. They committed the memorial to the safekeeping of the Corporation. The memorial is in the shape of an Eleanor cross. A civic procession crosses the square.

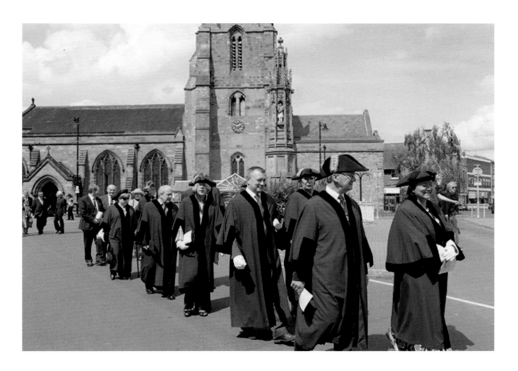

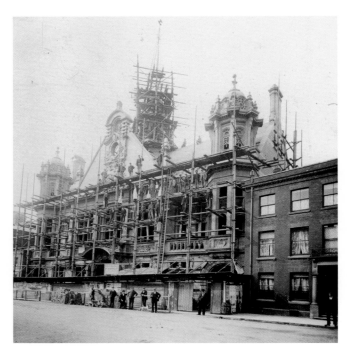

Town Hall, St Peter's Square

In Victorian times and earlier the civic offices were in the old town hall that stood on twenty-seven wood pillars in High Town. This was demolished in 1862. The town hall in St Owen Street was opened in 1904. It is built with terracotta and brick in the Renaissance style at a cost of £25,000. It was erected by Messrs Williams Bowers & Co. of Bath Street. Note the scaffolding in 2009.

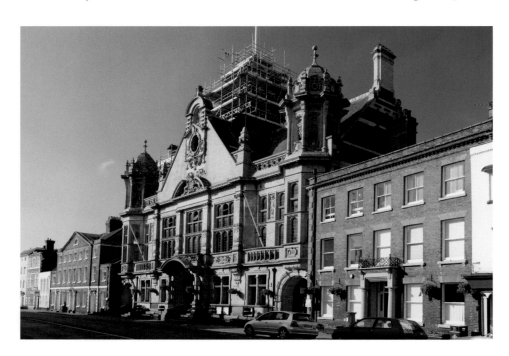

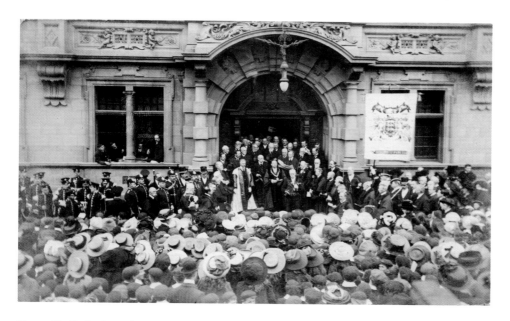

Town Hall, St Peter's Square, 1910

This busy scene is in front of the town hall on 10 May 1910. The proclamation of King George V was read in the presence of the mayor (Mr Walter Pilley), Sir James Rankin, MP (chief steward), Mr. J. S. Arkwright, MP, members of the Corporation, etc.

The mayor with the recently appointed chief steward, the Lord Temple Morris; his deputy, the Lord Carlile of Berriew; honorary recorder HHJ Toby Anderson Hooper; and lord lieutenant, the Countess of Darnley.

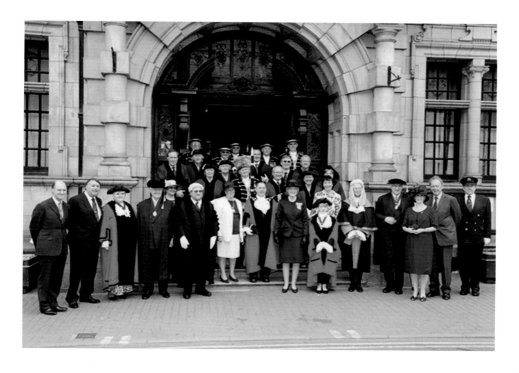

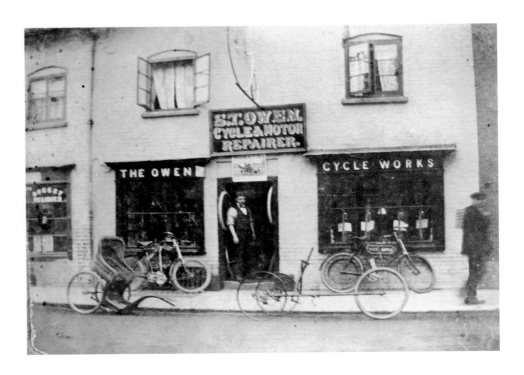

S. T. Owen's Shop, St Owen Street

Here in 1903 is Mr Owen, a motorcycle engineer, outside his shop in St Owen Street. Interestingly, he worked in his 'namesake' street. Mr Owen is in the doorway with some of his work on the pavement. Note the wicker seated trailer which would be attached to a motorcycle seat pillar. The motorcycle behind the seat is a Minerva, one of the earliest reliable makes of motorcycle.

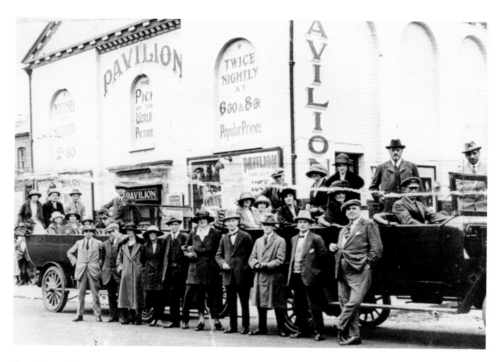

Pavilion Kinema, St Owen Street

'The Pavilion' cinema about 1925 at 74 St Owen Street. Between June 1919 and 1923 it was The Kinema and seated 368 people, but was closed in 1926 when the building was sold. The small picture was taken about 1917, when it was a chapel. It was listed in the 1895 directory as the 'Salvation Army Barracks'. The building has been a launderette for over forty years.

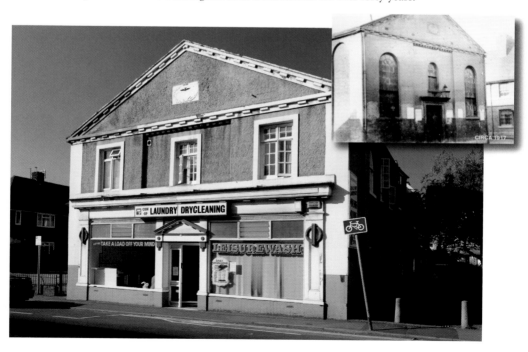

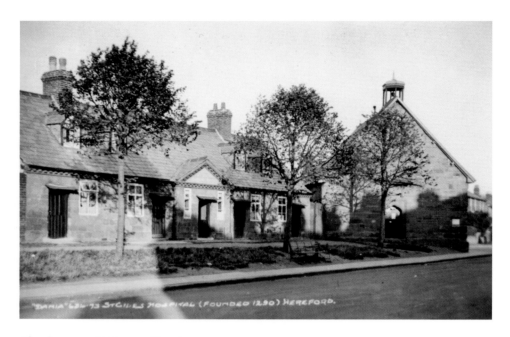

Almshouses, St Owen Street

At the junction of the Ledbury Road and St Owen Street on the left are the St Giles' Hospital almshouses, with the chapel protruding out well onto the pavement. Founded around 1290, in 1682 the almshouses were rebuilt using voluntary subscriptions. There are five houses, each with a piece of land. In 1927 the chapel was taken down for road widening and re-erected slightly nearer the city. In 1928 a plaque was placed on the new wall at the road junction.

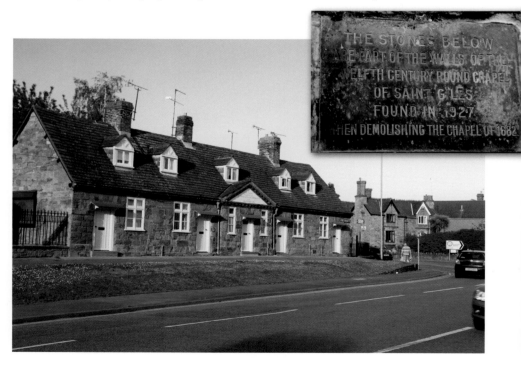

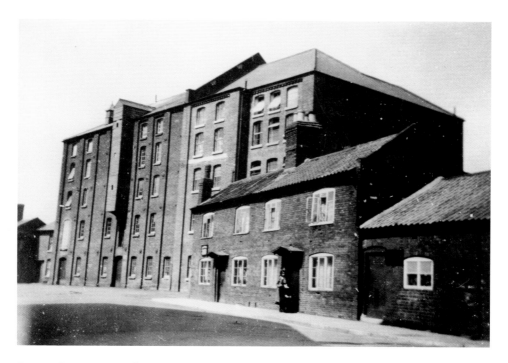

Berrow's House, Bath Street

In 1895 this building in Bath Street was described as the 'Industrial Aid Society's Flour Mills' where William Lloyd was secretary and manager. The society was founded by the Rev. John Venn, vicar of St Peter's, who helped the poor by letting allotments on nearby land. An invoice for 1902 advertised that they sold flour in free sacks weighing from 140 lbs to 280 lbs. The building is now a business centre.

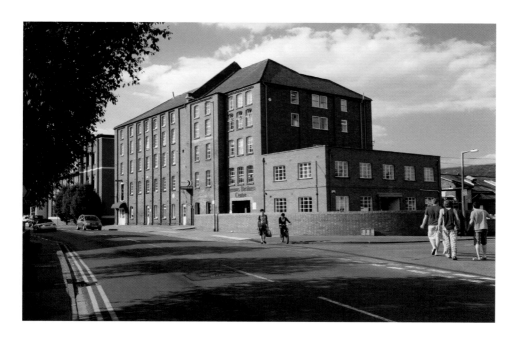

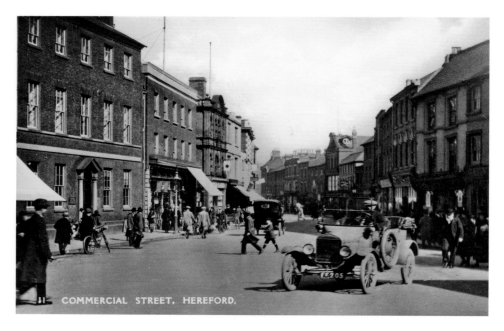

COMMERCIAL STREET, HEREFORD.

Commercial Street from High Town in 1928

The Georgian building to the left, 5 Commercial Street, was used as the judges' lodgings. This building was demolished to make way for the Odeon Cinema in 1937. The road traffic moved quite freely in both directions.

Today the new buildings are part of Maylord Orchards and can be seen on the left, while the road has been pedestrianised.

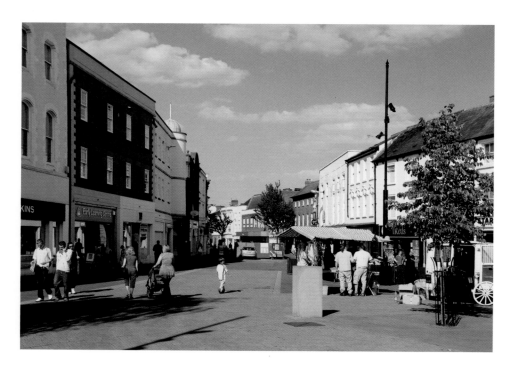

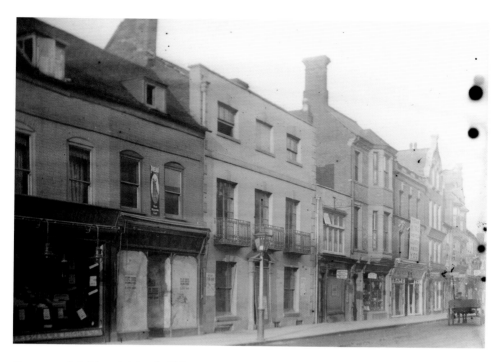

Commercial Street, North Side

In 1914 local architect Mr Bettington took this photograph of the north side of Commercial Street, just before he demolished the three closed shops behind the lamppost. The middle building with the tall chimney stack was a stationers owned by Mr Henry Brewer. The large sign on the shop reads 'Your King and Country need you' – the recruiting slogan for the First World War.

 The 'new' building has a 1915 date stone and is named 'Wilson's Chambers'.

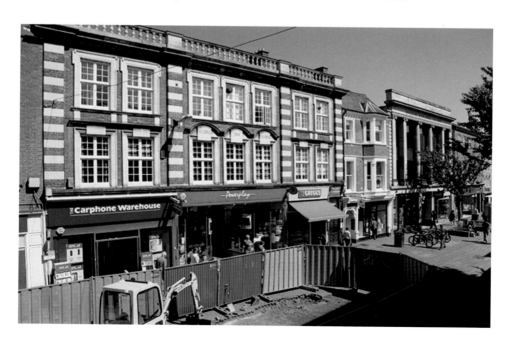

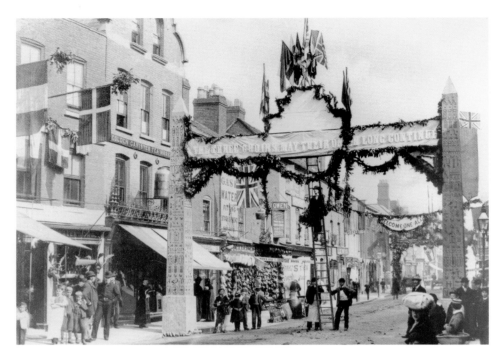

Three Choirs Festival Arch, Commercial Street

The Three Choirs Festival is held in Hereford once every three years. Here, in Commercial Street, workmen are erecting an elaborate festival arch across the road in 1906. There is another decorative arch in the background. Note the Egyptian Cleopatra's Needles with the banner inscription that reads 'The Three Choirs – long may their union continue'. A wall mounted copper kettle can be seen below the Union flag. Commercial Street was closed to traffic in 1989. The kettle survives and now hangs outside Waterstone's bookshop.

Coates' Shop, Commercial Street

A hundred years ago all Hereford jewellers were owned by local families. Here is Mr Coates of 49 Commercial Street, who advertised that he was not only a jeweller and clock maker, but also an optician. His window displays his stock. During the 1870s the upper floors were used as offices by the early charity the Society for Aiding the Industrious, founded by the Rev. John Venn.

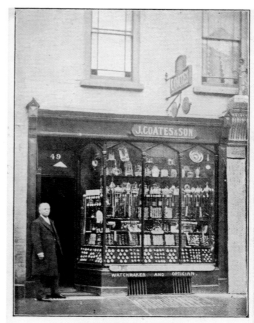

J. COATES & SON,
Watch and Clock Makers, Jewellers, and Opticians,
49, COMMERCIAL STREET, HEREFORD.
SPECIAL ATTENTION GIVEN TO REPAIRS.

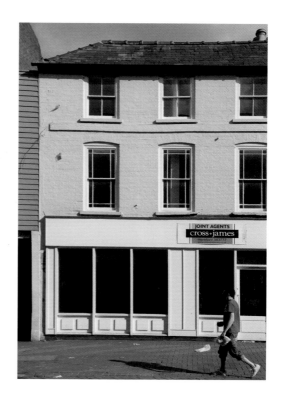

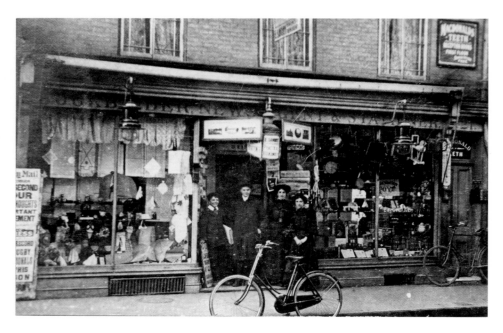

Commercial Street

William Price, a newsagent in Commercial Street, is outside his shop with three assistants. The prominently placed bicycle looks new. The news board advertises the *Daily Mail* and the *Daily Express*. In the left window can be seen jewellery, handkerchiefs and clothes while on the right are pipes, tobacco and accessories. The MacDonald's teeth sign is above the dentist's entrance.

This shop front is from the 1980s, but inside the upstairs is half-timbered.

Vaughan's Shop, Commercial Street

Queen Victoria's Diamond Jubilee was celebrated nationally and in the colonies. This 1897 photograph of Commercial Street includes Mr Christopher Vaughan and staff outside his shop which has been specially decorated for the occasion. All the men are wearing their Sunday best – suits and hats. Mr Vaughan was a builder and sanitary engineer. Next door, to the left, is the Vaughan & Co. Steam Laundry.

Inside is a range of ancient timber frame buildings, the oldest part of which dates back to about 1540.

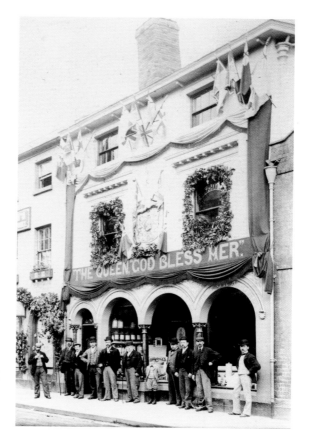

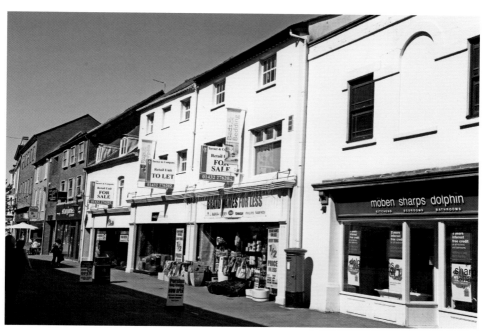

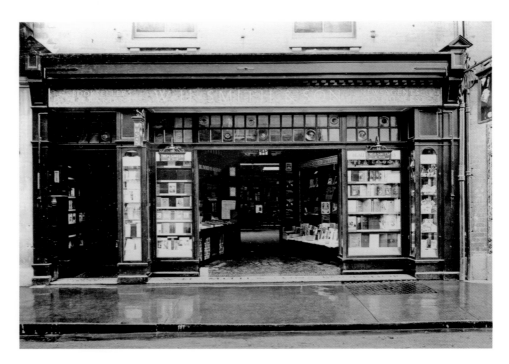

W. H. Smith, Commercial Street

W. H. Smith's first retail outlet was a bookstall at the railway station. In 1906 they opened their first shop in Stonebow House, Commercial Road, now the site of Lidl's. In 1909 they moved into no. 46 Commercial Street. This is the shop in 1922. The side entrance leads upstairs to the Wye River Board. Photo courtesy of W. H. Smith archives.

In 1991 W. H. Smith moved out of Commercial Street into High Town (see page 13).

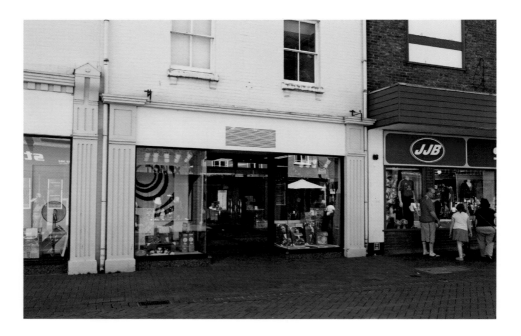

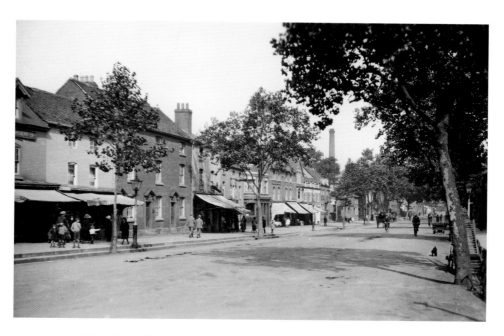

Commercial Road, looking North-East

Here we are in the middle of Commercial Road looking towards the north-east and the junction with Monkmoor Street. The row of shops included a taxidermist, bicycle agent, a servants' registry and bootmaker. The Great Western Inn is visible on the far side of the road junction. Note the steps up to the pavement.

The buildings remain, even if the chimney pots do not. The change of use of all the buildings can be seen. The Great Western is now no longer an inn but a Chinese restaurant.

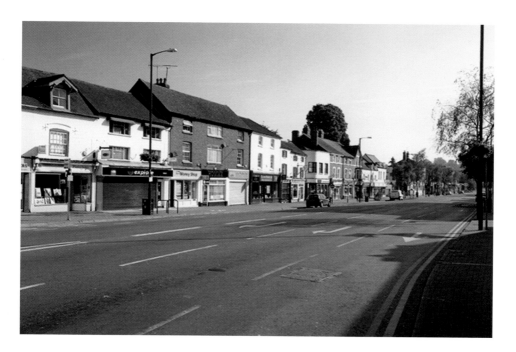

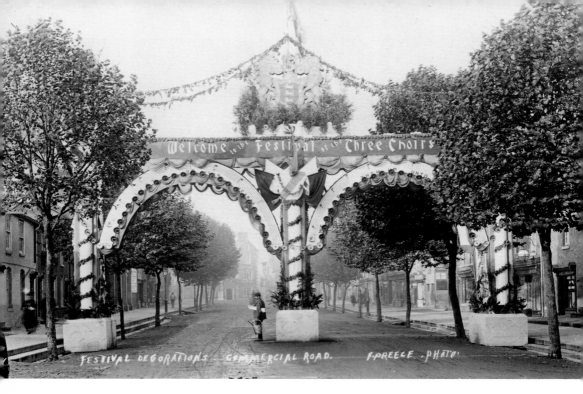

FESTIVAL DECORATIONS - COMMERCIAL ROAD. F.PREECE .PHOTO.

Three Choirs Festival Arch, Commercial Road

Commercial Road in September 1906, towards the Kerry Arms Hotel. The huge decorative twin arch built across the road is surmounted by the city coat of arms and was erected for the Hereford Three Choirs Festival. Behind the trees to the left is Greenland's furniture depository, and to the right is the entrance to Monkmoor Street, with the Great Western Inn on the corner.

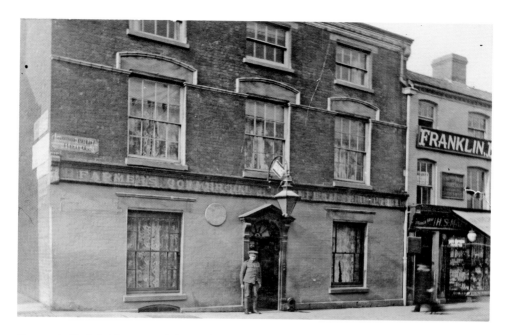

Farmer's Hotel, Commercial Road

Mr Rodgers, the owner, stands outside his Farmer's Commercial Temperance Hotel at the junction of Commercial Road and Blueschool Street, about the turn of the last century. The hotel has a Georgian design with interesting stonework above the windows. Note the hanging gas lamp above the front door. Next door is Franklin Barnes shop, a seed and corn merchants. Franklin Barnes House (recently purchased by Herefordshire Council) has become a well-established landmark.

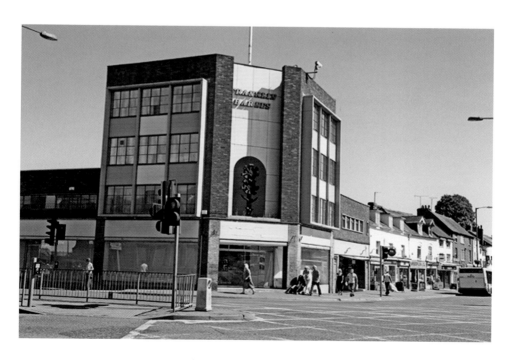

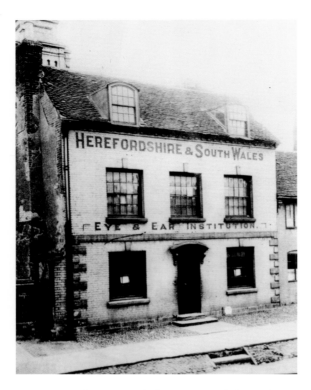

The Eye and Ear Hospital, Commercial Road

The Herefordshire and South Wales Eye and Ear Institution was established in Commercial Road by the Hon Surgeon Mr F. W. Lindsay in July 1882. It opened 1 January 1884 as a public institution. The building proved to be too small and unsuitable. In Queen Victoria's Jubilee year, 1887, funds were raised to build a new hospital that opened on 20 August 1889 on Eign Street. Note the church turret on Eign (see page 85). The loss of the old hospital has opened up the full frontage of the church to Commercial Road.

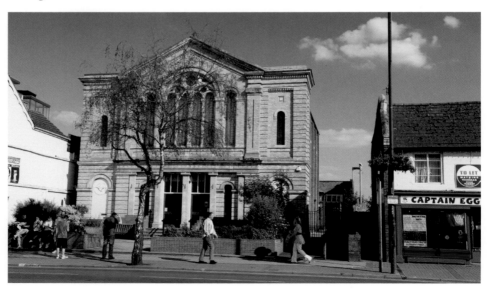

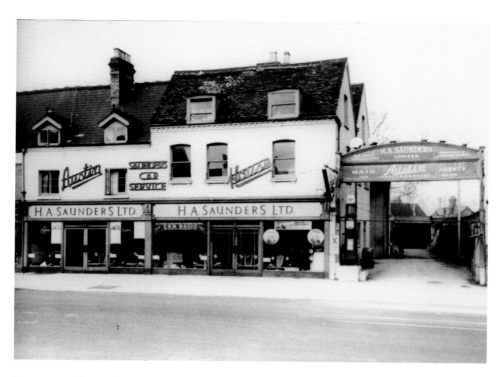

H. A. Saunders Ltd, Commercial Road

In 1938 H. A. Saunders Ltd purchased this building and opened a garage called Austin House. There is a petrol pump under the archway entrance to the workshops at the rear of the building. There are six cars visible in the showroom with an advert for car radios on the window. Austin being a popular make, there would have been many local people who purchased a car here.

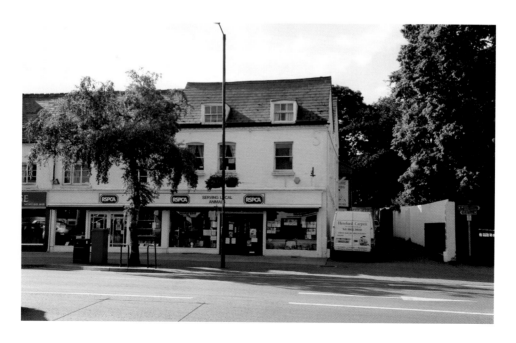

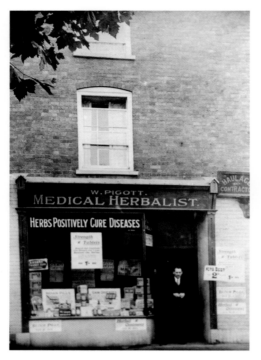

Pigott's Herbalist Shop, Commercial Road

The treatment of disease with herbs is said to be as old as mankind itself. Here is Mr W. Pigott outside his Herbalist's shop (about 1930) in Commercial Road. It was the only one in the county and continued in business until 1960. He was a local character and served as a Labour Councillor. He was made alderman in 1947 and mayor in 1949. The window sign reads 'Herbs positively cure diseases'.

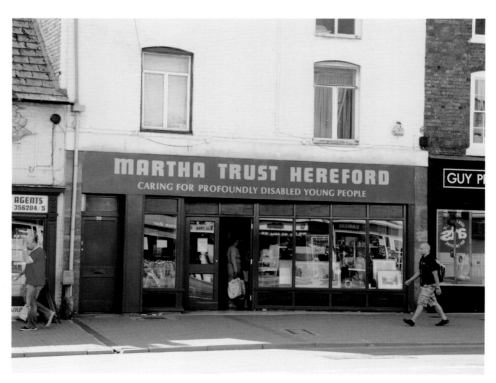

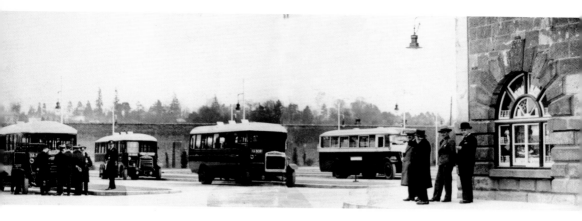

Panorama of Hereford Bus Station

This view was taken in 1937 at the 'new' bus station, on the site of the old Prison where in 1895 Joseph Flockton was chief warder and acting prison governor. Before the old gaol was demolished in 1935, local people were invited to inspect the buildings on payment of 6d. The former Governor's House was retained and converted into a waiting room and enquiry/booking offices for two major bus companies.

The cast iron shelter erected just before the war is attached to the Governor's House.

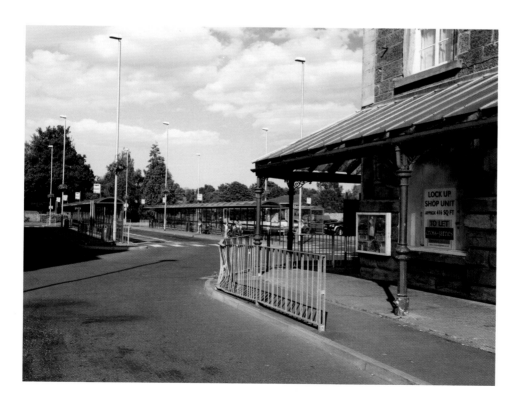

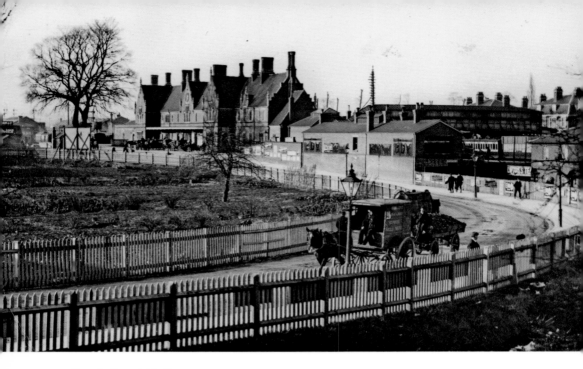

Barr's Court Station

Barr's Court Station about 1908. The railway line from Shrewsbury to Hereford Barr's Court was opened in 1853. The station building was opened in 1855, as was the line to Ross and Gloucester. In 1861, the line to Worcester was opened while the line to Hay and Brecon opened three years later. By 1893 the station was the centre for all rail travel in Hereford. The station building is listed and awaits tenants in the upper floors of the station.

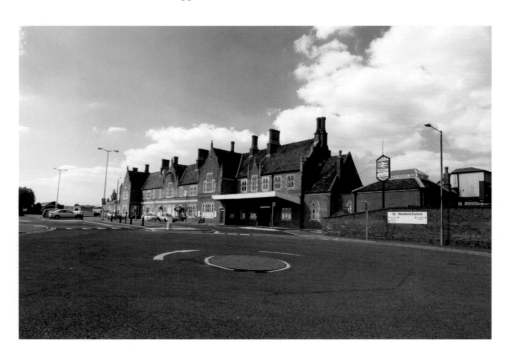

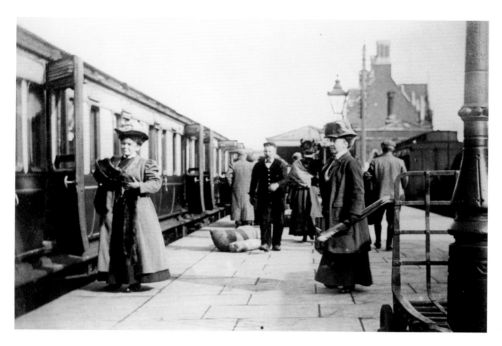

Barr's Court Station Platform

The northbound platform in Hereford Railway Station, taken by Mr Zimmerman in the early 1900s. The very well dressed ladies are just about to board the first class carriage at the platform. Photograph from the late Basil Butcher's collection.

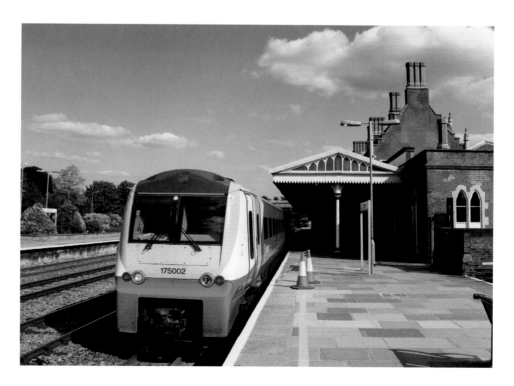

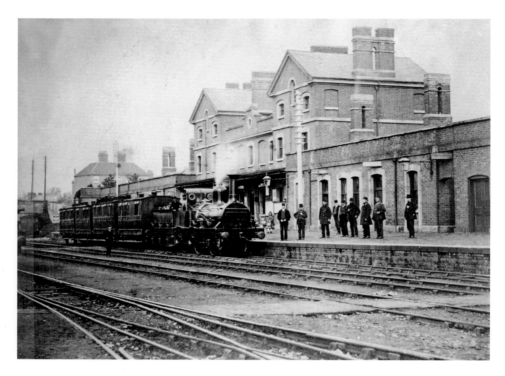

Barton Railway Station

In the mid-Victorian period Barton Station trains departed for Newport and Abergavenny. Barton Station seen in this picture was closed to passenger traffic in 1893, following an agreement for the Midland Railway to use Barrs Court. Barton survived for freight use until 1979. Little now remains of the original view except the distant house. The car park is on the old station site, and the old Whitecross Street railway bridge was replaced with a pedestrian tunnel.

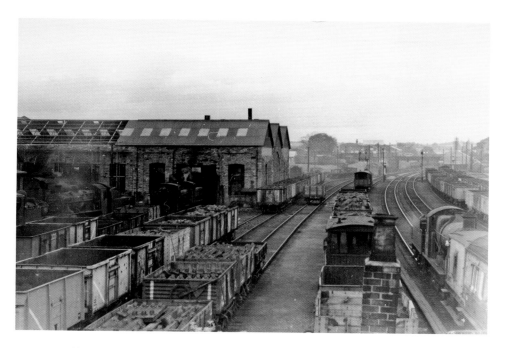

Barton Railway Engine Sheds

Barton goods yard and engine sheds about 1950. This view from the Barton Road railway bridge towards the Eign Street railway bridge shows a lot of activity. The railways carried most of the nation's freight. This rapidly declined during the following decades. Photograph by Mr. H. B. Priestley. A telephone exchange, blocks of apartments, hotel and bar, the Railway Club and J. Sainsbury's now occupy the site.

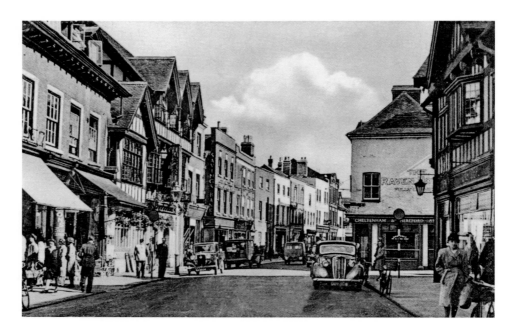

Widemarsh Street

Widemarsh Street about 1946 showing traffic travelling in both directions and plenty of space to park. To the left is the Mansion House, which in January 1907 was the Municipal Surveyors, Gas, Water Works and Rates Office. The shop on the left was G. Wright and Son, fruiterers, while to its right was R. J. Jenkins, outfitters. Next door is the Imperial Hotel, which is an early twentieth-century reproduction half-timbered building. Reproduced from an original Frith & Co. postcard. The street is now pedestrianised from 10.30 a.m. to 4.30 p.m.

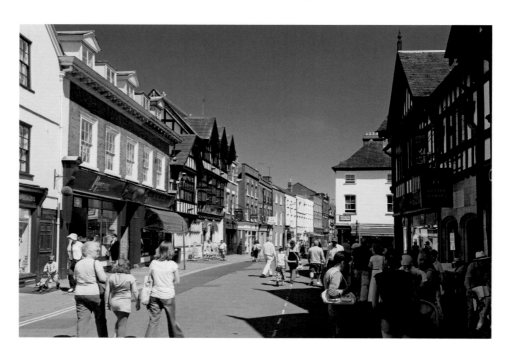

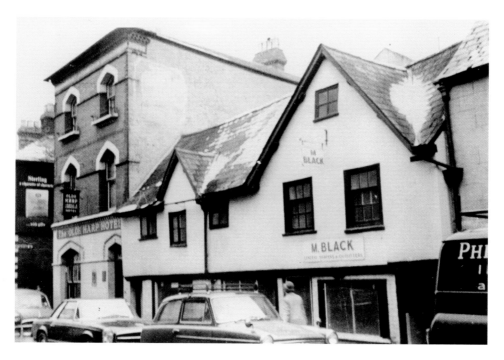

Black's Shop, Widemarsh Street

M. Black's shop in Widemarsh Street about 1966, prior to the construction of the inner relief road. Behind the shop is the Old Harp Inn where F. G. Hitchcox was landlord. The building just visible on the extreme right was a butcher on the corner of Blueschool Street and Widemarsh Street. M. Black's shop, a general drapers and outfitters, was an attractive timber framed building with a rendered front. Photograph, courtesy of Jean O'Donnell. The buildings were demolished to make way for the inner relief road in 1968.

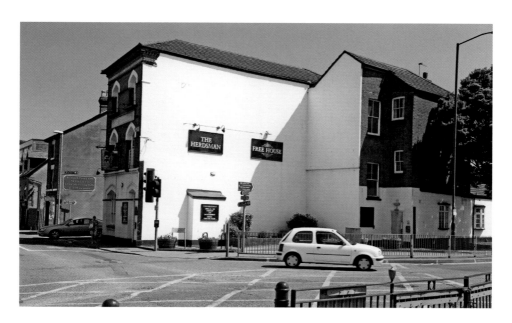

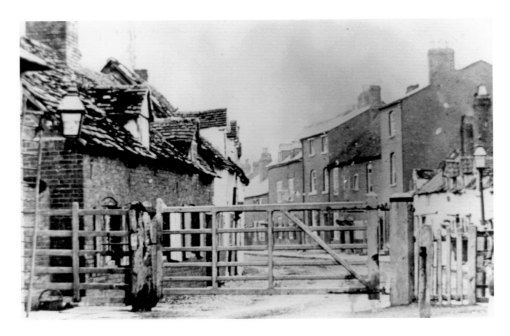

Widemarsh Street Toll Gate

Turnpike gates were established in 1663 where tolls were taken from passengers and vehicles to pay for the upkeep of the roads. They were abolished in 1870. In 1888 the Local Government Act put the responsibility of maintaining main roads on to the county councils. This is Widemarsh Gate where the second building on the left is the Essex Arms, occupied by Mrs Sophie Parry (see page 77). In the background at 75-78 was Symond's Hospital founded in 1695 for four persons.

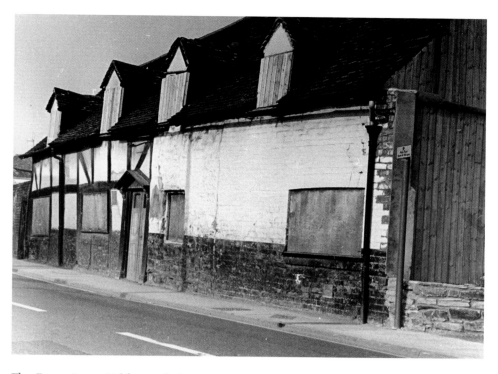

The Essex Arms, Widemarsh Street

The final days (1985) of the Essex Arms, Widemarsh Street, once sold in 1930 for £3,600 to the Stroud Brewery owner Mr A. J. Perrett.

The Essex Arms was dismantled and in 1989 re-built at Queen's Wood on Dinmore Hill. Though now preserved in a rural environment this building was a loss to the city (see page 76).

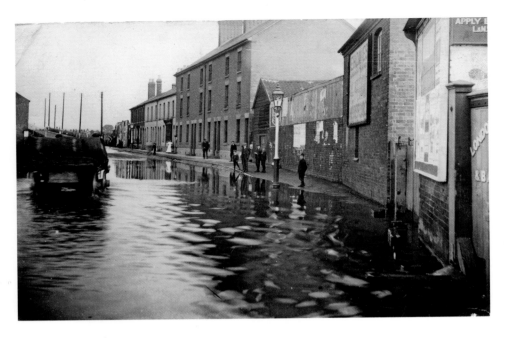

Newtown Road

The date is just after the Great War, a horse drawn delivery wagon trundles slowly through the Newtown Road flood. The Tan Brook frequently flooded the road here. In the distance is the post office with a bakers' shop next door. Coal merchant, Albert Baker traded from his premises on the right.

This road still floods, though a proposed flood diversion culvert near Credenhill to the River Wye may reduce this problem. The view photographed after heavy rain shows a recent flood outside the new houses.

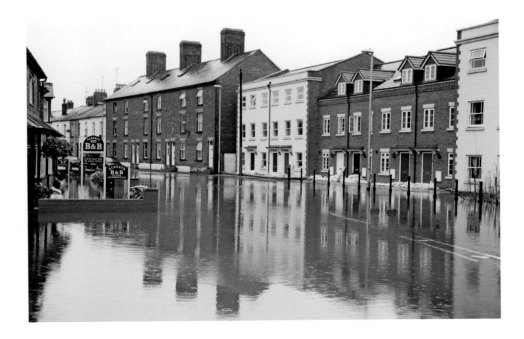

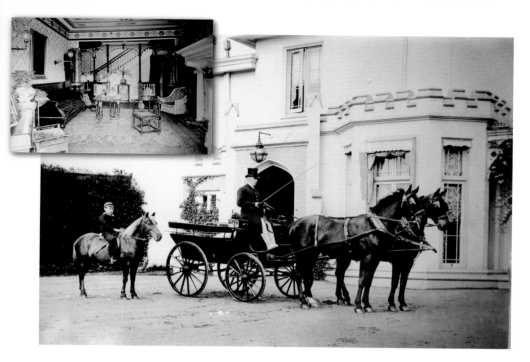

Venns Lane, Elmhurst

At the turn of the twentieth century Venns Lane had five large houses and several cottages. The carriage driver waits for his passengers outside 'Elmhurst' in 1898. The house is near the junction with Aylestone Hill. In 1898 Elmhurst was owned by the Boulton family who also owned Barrs Court Cider Stores in Rockfield Road where they had a cider factory. The small boy on the pony is the son.

The local authority owned and ran the house as a residential home that has now closed. Photographed with permission of Herefordshire Council.

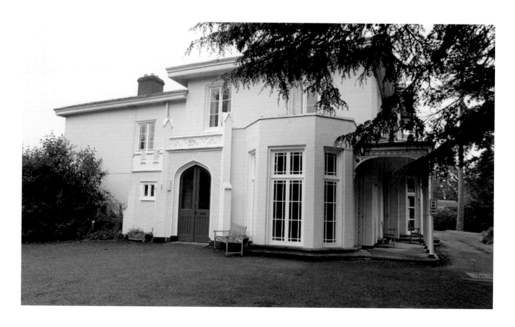

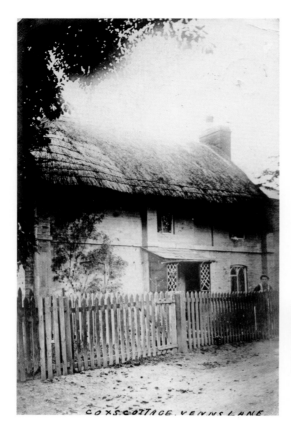

COXS COTTAGE. VENNS LANE

Cox's Cottage, Venns Lane

The cottage in Venns Lane from a postcard dated 1905 shows Thomas Pitt a carpenter watching the photographer. It was home to the famous Victorian watercolour artist David Cox, 1783-1859, who for some years taught art at the Academy for Young Ladies, now the Farmers Club, in Widemarsh Street. Note the window above the entrance porch, which has been bricked up.

The roof was re-thatched in 1987 with imported French reeds that should last for over eighty years. The cottage is a Grade II listed building.

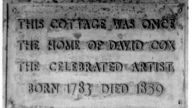

THIS COTTAGE WAS ONCE
THE HOME OF DAVID COX
THE CELEBRATED ARTIST
BORN 1783 DIED 1859

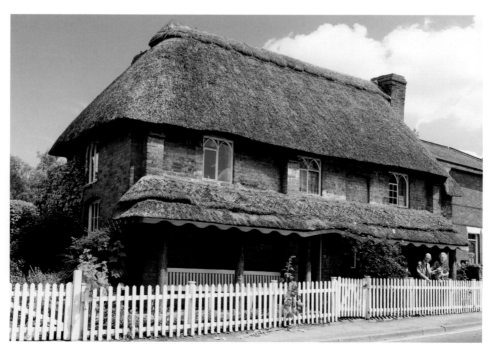

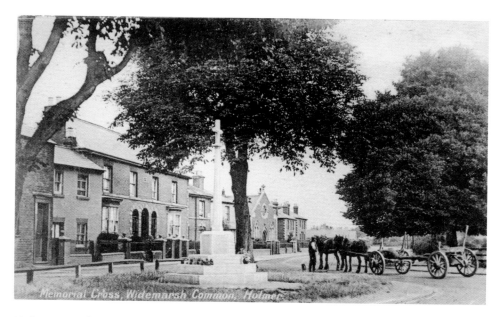

Memorial Cross, Widemarsh Common, Holmer

Holmer Road War Memorial

Holmer Road, Grandstand Road and Newtown Road junction about 1920 (view to the north along Holmer Road). The horses are on their way home after delivering a load of timber in the city. The memorial looks very new with flowers on the second step.

A new mini roundabout facilitates easier traffic flow at this junction. The memorial has been removed and re-erected on the far side of the Widemarsh Common.

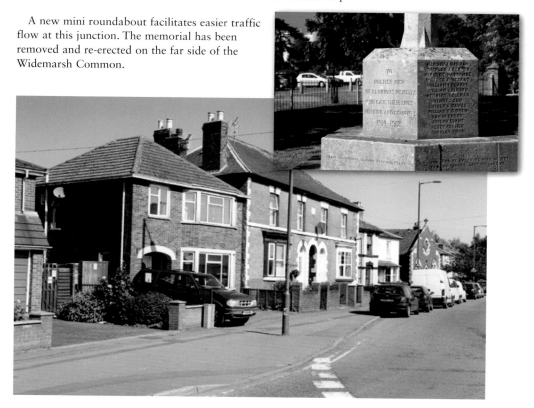

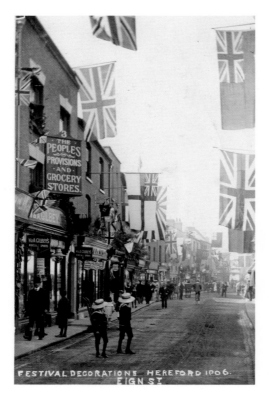

FESTIVAL DECORATIONS HEREFORD 1906.
EIGN ST.

Eign Street View With Flags

Eign Street decorations celebrating the Three Choirs Festival in 1906. The large flags almost form an arch across Eign Street. This view towards the east shows Clarkson's and Stewart's Peoples Stores with a board advertising Gilbys wines and spirits. Next door is Thackway's, the tobacconist. Seven shops further on is Jennings, a saddler.

The street was pedestrianised many years ago and recently refurbished. Of the businesses in the earlier photograph, only Jennings the saddlers survived into the 1990s.

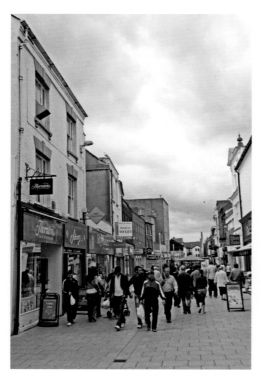

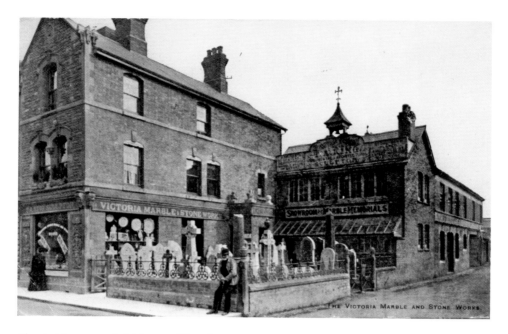

King's Monumental Mason, Eign Street

This rather grainy Wilson and Phillips postcard of around 1904 clearly shows T. A. King's Victoria Marble and Stone Works and the large yard with stone memorials. They were at the junction of Eign Street and Victoria Street. A 1907 catalogue and photograph for these premises indicates that it had become the Hereford Motor Co. The building was demolished in 1967 to make way for road widening.

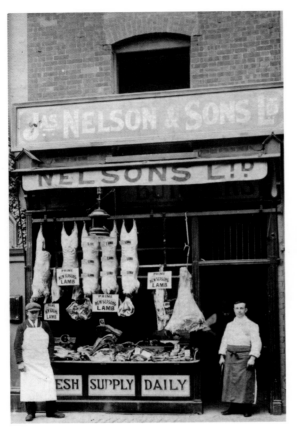

Nelson's Butchers, Eign Street

In 1900 Hereford had over thirty butcher's shops, so the trade was fairly substantial. The old Butter Market had ten butchers. Without refrigeration one wonders how long the meat could be stored. This is Nelson's shop in Eign Street about 1912. Mr Nelson is just visible inside and his sons outside. The whole display is labelled 'Prime New Season's Lamb' and 'fresh supply daily'.

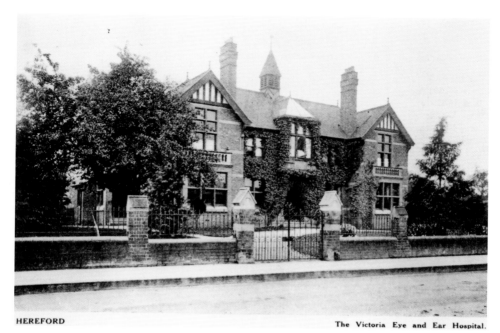

HEREFORD The Victoria Eye and Ear Hospital.

Eign Street Eye Hospital

The Victoria Eye and Ear Hospital was established under the name Herefordshire and South Wales Eye and Ear Institution in July 1882. This hospital in Eign Street was opened 29 August 1889. This photograph was taken about 1910, when the hospital had beds for 20 patients and 2,000 outpatients were seen each year (see page 66). The building was sold and has been converted into apartments.

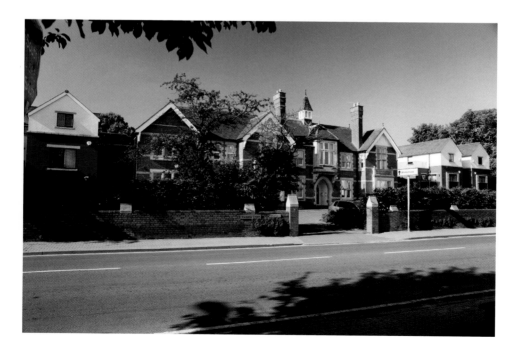

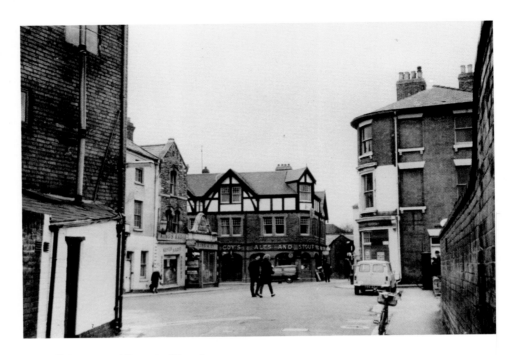

Bewell Street to Victoria Street

A distant police man outside the Red Lion controls the traffic at the Victoria Street, Edgar Street and Eign Street junction in 1967. This was just prior to the building of the inner relief road. The building on the left is part of Edwards's hairdressers. The more distant light coloured building is Charles Parry's butcher's shop. Next door can be seen King's radio and cycle shop. Photograph courtesy of Jean O'Donnell. The Red Lion flats are on the centre left, with Steel's car sales on the right.

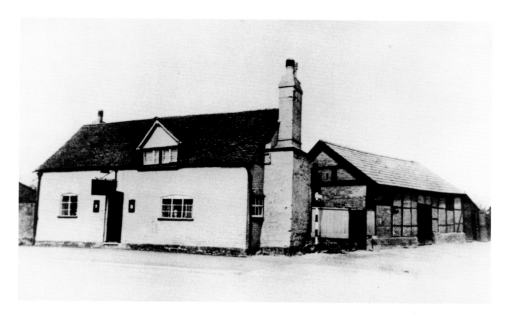

Plough Inn, Whitecross Road

The Old Plough Inn on the corner of Whitecross Road and Plough Lane. The timber framed coach house is on Plough Lane, which leads to Canon Moor Farm and the Midland Railway Inn. In 1934 it was listed as Ye Old Plough Inn run by Mrs Rosa Bailey. By 1955 Mr Woodward was the new landlord. On the lane to Canon Moor Farm were Sweetman & Son hauliers, Hereford Petroleum Co. and Asphalt Public Works.

 This 1930's building has enhanced this corner.

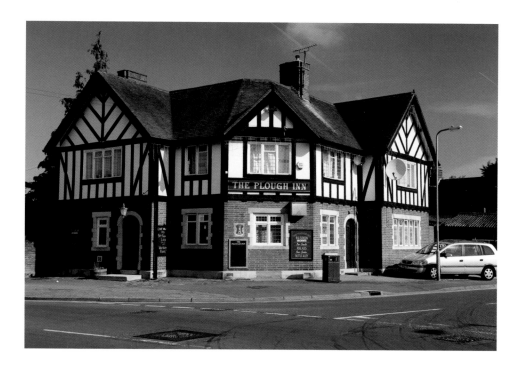

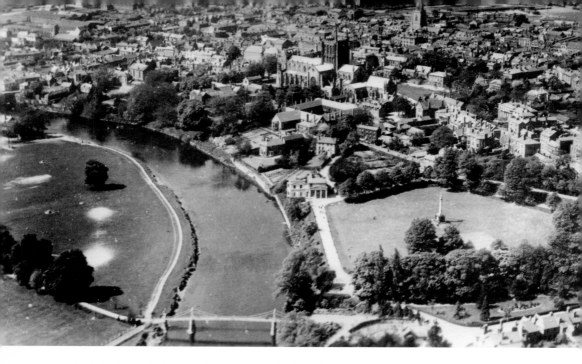

Aerial View of the Castle Green and Victoria Bridge

Early aerial photographs of Hereford are of special interest. This is the River Wye, Castle Green, Victoria Bridge and Cathedral taken about 1920. The Bishops Meadow is grazing land with parch marks and the Castle Green is surrounded by trees. Virtually the whole of the city centre is visible. The bowling green (on the Castle Green) is only just defined and has no visible protective fence. It was opened in 1908 by Councillor J. Mitchell.

The author took this photograph in 2007 when the Bishops Meadow was partly flooded.

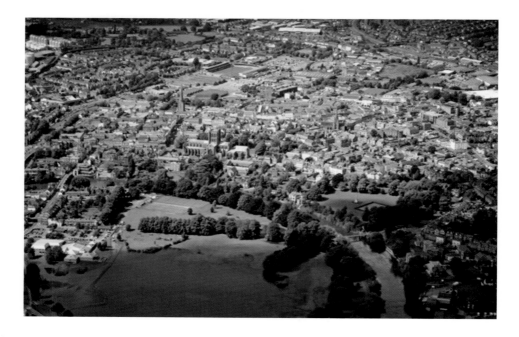

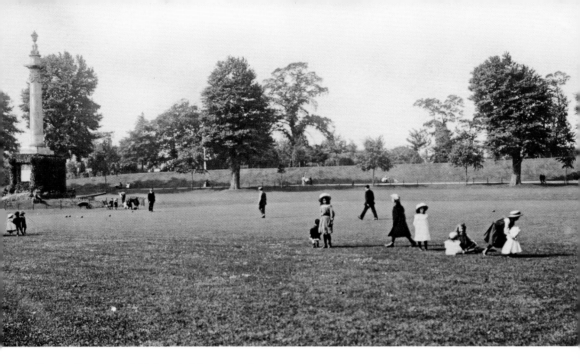

Castle Green and Nelson's Monument

Castle Green, on the site of Hereford Castle, was a popular spot in Victorian and Edwardian times. The City Corporation Parks Department have recently planted trees on the far side. The green was first used as a public park in 1753. Nelson's column is 60 ft high and erected in commemoration of Lord Nelson, who was killed at Trafalgar in 1805. Note the cannons at the foot of the Nelson Monument. The bowling green now dominates the southern part and is protected by a thick hedge.

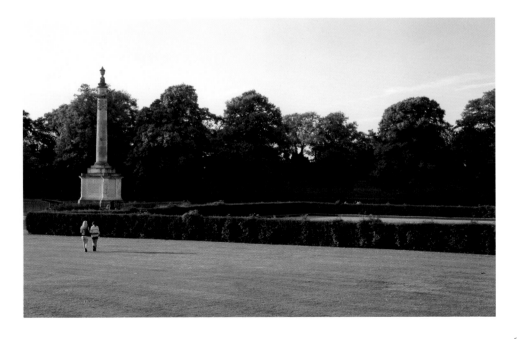

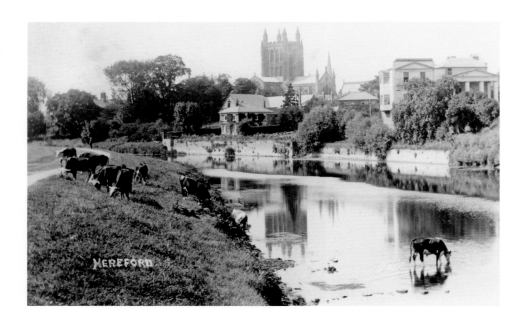

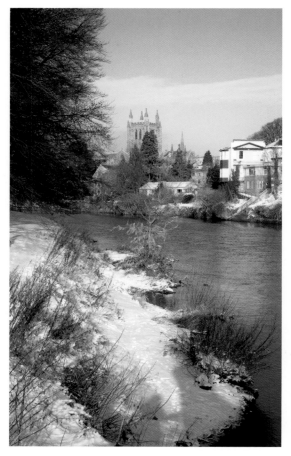

River Wye and Cathedral

The cathedral, Hereford College of Art and River Wye, pictured in about 1925 when the principal of the college was Henry Baynton. The white-faced Hereford cattle graze and drink along the Wye banks. The Hereford Herd Book Society in East Street is the worldwide centre for recording the pedigree. The old college buildings (on the right) are now used by Herefordshire Council as a conference and teaching centre, as well as for storage and meetings by the Canoe Club. On both banks the trees have grown significantly.

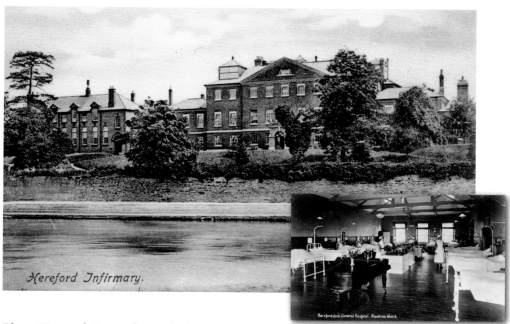

Hereford Infirmary.

Herefordshire General Hospital. Hawkins Ward.

River Wye and General Hospital

The Hereford Infirmary, photographed in 1910. This building dates back to March 1776 and was built on land donated by the Earl of Oxford. The founder of the Hereford General Infirmary was the Rev. Thomas Talbot of Ullingswick. In 1928 it was reported that there were eleven wards and two isolation wards. The hospital could accommodate 125 patients (fifty male, fifty female and twenty-five children). It was supported by subscriptions. The old hospital is now closed and converted into apartments.

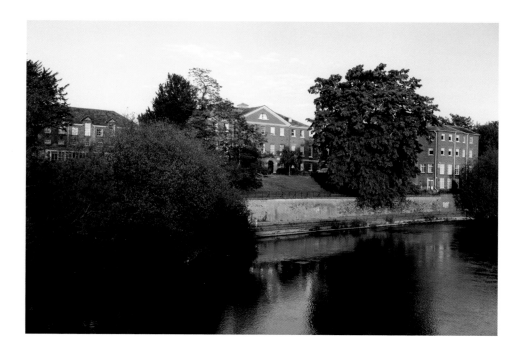

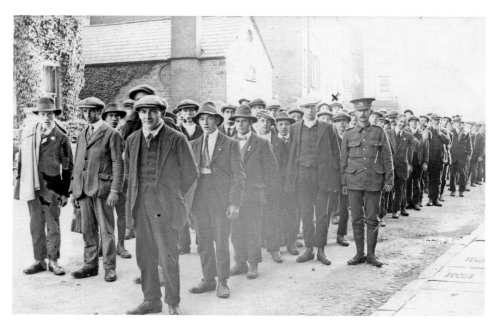

Recruiting Parade, St Ethelbert Street

A recruiting parade in St Ethelbert Street during 1914. The Castle Pool Hotel faintly appears in the background. No doubt these recruits joined the Herefordshire Regiment and fought in the trenches. This postcard has a cross marked and on the reverse, dated 26 September 1914, is signed 'Wilf'. St Ethelbert Street is in a conservation area and no new houses have been built for well over a hundred years.

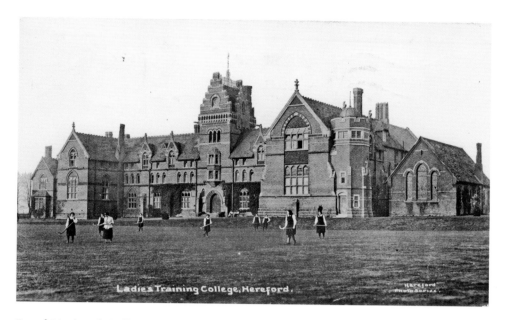

Ladies Training College, Hereford.

Royal National College, College Road

The Ladies Training College, Hereford, around 1910. The buildings were erected in 1880 in the style of the Victorian Gothic revival, complete with narrow ecclesiastical windows and a central tower. It was originally a boys' school but was not a success and wound up in 1903, when it was put up for sale. It was a teacher training college for over seventy years. The buildings are now occupied by the Royal National College for the Blind, founded in 1872, which moved to Hereford on 1 October 1978. The author thanks the Acting Principal for permission to take this photograph.

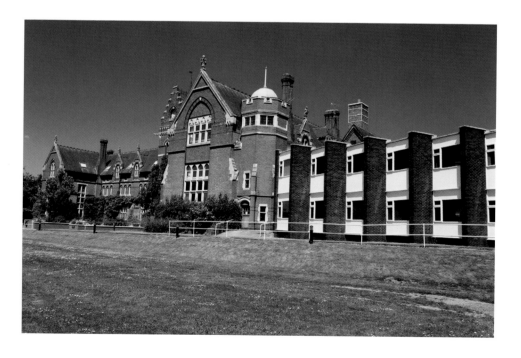

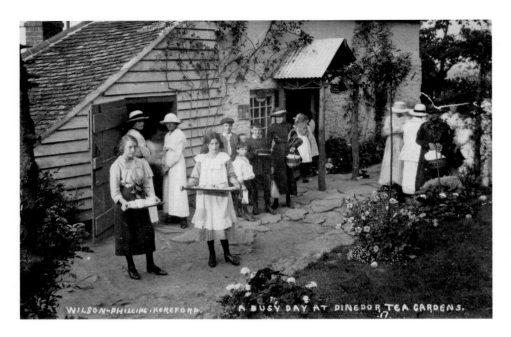

WILSON-PHILLIPS·HEREFORD. A BUSY DAY AT DINEDOR TEA GARDENS.

Dinedor Tea Rooms

Dinedor Tea Gardens was at the top of Dinedor hill just over a mile outside the city boundary. On Sundays during good weather many Herefordians would walk up to the top of the hill for the view and, no doubt, a cup of tea. Here we see numerous visitors and girls with tea trays. In 1905 the owner was Frank Harrison of Dinedor Camp. The cottage has been extended and is now used by the County Council youth services.

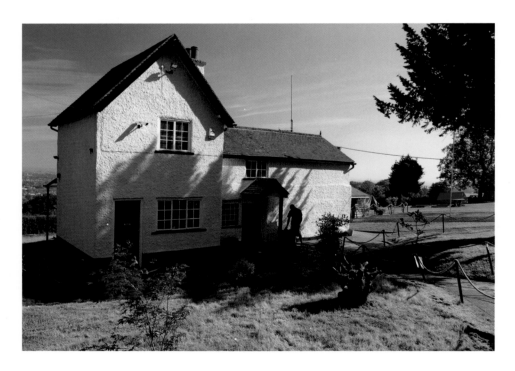

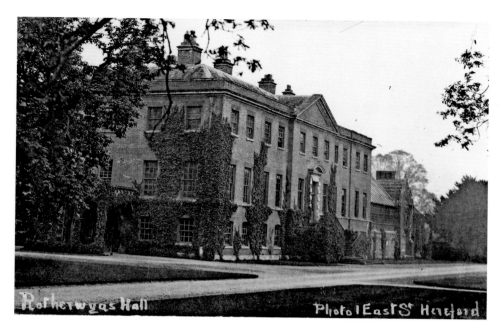

Rotherwas Hall

Pictured in about 1906, this large stately home just outside the city was built in 1731, on the site of an earlier mansion. The last owner was Count Louis Bodenham-Lubienski (d. 1909). The hall contained some very fine oak carvings taken from the older house and the estate covered 1,628 acres. Some of the panelling is now incorporated into Amherst College, Massachusetts, USA. The house was finally demolished in 1925. The nearby Rotherwas Chapel survives.

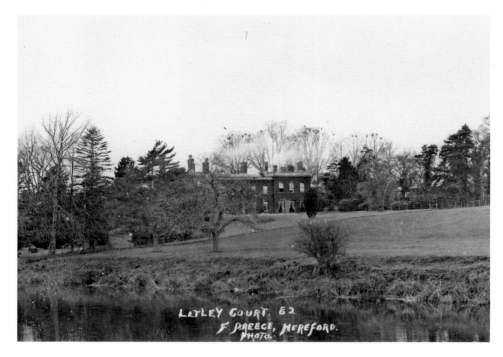

Litley Court, Hampton Park Road

Litley Court was the centre of a large Victorian estate, which was sold at auction in many lots by auctioneer Mr. Edwin Stooke on 7 September 1877. One building on the estate, Drayton House, later renamed Plas Gwyn, was to become the home of Sir Edward Elgar. Litley Court was resold in 1884 when it had only 32 acres. Today the house is divided into several apartments.

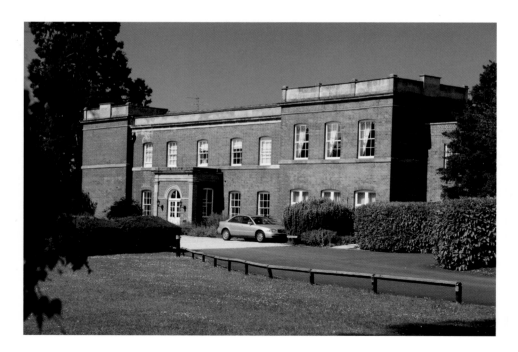